# Mastering MANGA

## With Mark Crilley

IMPACT
CINCINNATI, OHIO
www.impact-books.com

# Contents

Hey there, everybody! I'm Mark Crilley.

If I had to summarize my approach to drawing manga in just a single sentence...

...it would be this: beware of the "close enough" mentality.

Here's what I mean. The only way to make an authentic manga illustration is to draw all the lines in the right place. In *exactly* the right place.

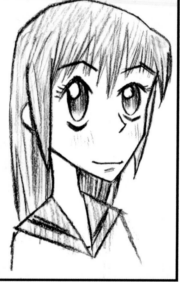

We've all seen drawings that almost look like real manga.

The problem with them is they are based on the belief that all you need to do is give a character big, shiny eyes and that will be close enough.

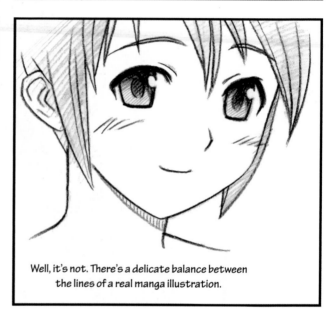

Well, it's not. There's a delicate balance between the lines of a real manga illustration.

The eyes, the nose, the mouth and all the other parts of the drawing are a very precise distance from one another. In this book, I'll show you where the lines belong and help you get them there in your own drawings.

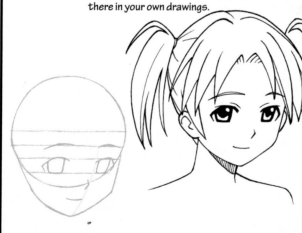

Okay, we're almost ready to start drawing! But first let's look at some supplies you'll need.

# What You Need

Many aspiring artists worry too much about art supplies. There almost seems to be the belief that buying the right stuff is the single most important key to creating great art, but that's like thinking you'll be able to swim as fast as Olympic gold medalists do by wearing the right swimsuit. It doesn't work that way.

What really matters is not the pencil but the brain of the person holding it. Experiment to find the size, styles and brands you like best. If it feels right to you, that's all that matters.

## Paper

I almost want to cry when I see that someone has put hours and hours of work into a drawing on a piece of loose-leaf notebook paper. Do yourself a favor and get a pad of smooth bristol. It's thick and sturdy, and can hold up to repeated erasing.

## Pencils

Pencils come down to personal preference. Perfect for me may be too hard or soft for you. I like a simple no. 2 pencil like the sort we all grew up with, but there are pencils of all kinds of hardness and quality. Try some out to see what kind of marks they make. The softer the lead, the more it may smear.

## Pens

Get a good permanent-ink pen at an art store, one that won't fade or bleed over time. Don't confine yourself to super-fine tips. Have a variety of pens with different tip widths for the various lines you need.

## Rulers

Get yourself a nice, clear plastic ruler so that you can see the art as you make lines. A 15-inch (38cm) ruler is good for even some of the longest lines.

## Kneaded Erasers

These big soft erasers, available in art stores, are great for erasing huge areas without leaving tons of pink dust behind. However, they aren't always precise, so feel free to use them in combination with a regular pencil eraser.

## Pencil Sharpeners

I've come to prefer a simple hand-held disposable sharpener over an electric one. You'll get the best use out of it while the blade is perfectly sharp.

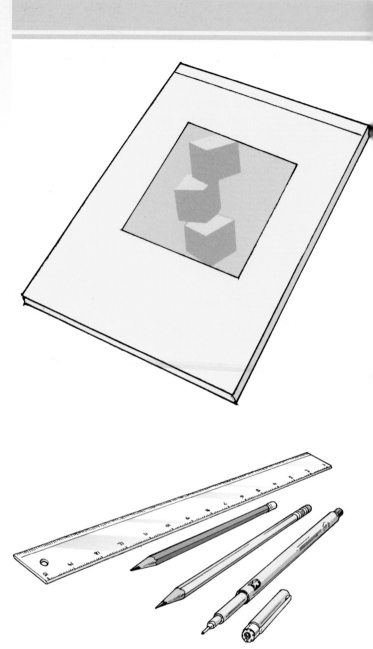

# Making the Manga Eye

Let's get started with a warm-up exercise. Here's a step-by-step demonstration that will get you used to the process we'll be using. Eyes are a great place to begin drawing as they are key to the characters, simple yet even if you've never drawn before.

**MATERIALS**

bristol board

clear plastic ruler

kneaded eraser

no. 2 pencil

pencil sharpener

pens in a variety of tip thicknesses

**1** Pencil in two horizontal lines 1 inch (25mm) apart. Connect them with four vertical lines, each an equal distance apart. The three shapes that result should be slightly taller than they are wide.

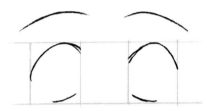

**2** Draw the eyebrows, and upper and lower lash lines. The angle of each line tilts up slightly toward the center of the drawing. The upper eyelashes' curves are more pronounced. Your guidelines help get the proper distances for the lash lines, but for the eyebrows you need to use your judgment to get the correct space between each line and the lash lines below.

**3** Add the iris of each eye, leaving a small white circle at the top for the highlight.

**4** Place an oval behind the highlight within each iris. Add a smaller loop within each of those ovals to indicate the pupils. Extra credit if you replicate the slight flattening of the bottom of the ovals as they near the lower eyelashes. Add two curving lines above each eye for the eyelid folds.

**5** Use your pen of choice to ink. If you've been careful, you now know exactly where to put the heavy black lines.

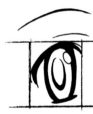

**6** Once the ink dries, erase all the pencilled guidelines.

### Keep Your Pencil Lines Light!

The pencil lines in the step-by-step lessons of this book appear bold black for clarity, but you'll want to keep them quite light in your own drawings. Pencil lines need to be erased after inking.

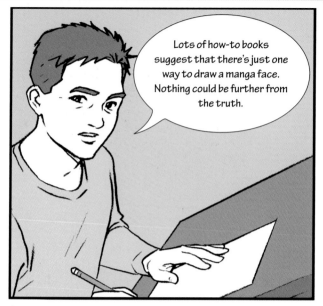

Lots of how-to books suggest that there's just one way to draw a manga face. Nothing could be further from the truth.

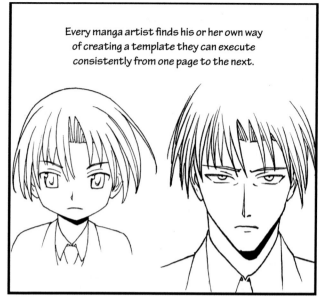

Every manga artist finds his or her own way of creating a template they can execute consistently from one page to the next.

There are dozens of variations. I wish I could show you how to draw them all, but space won't allow.

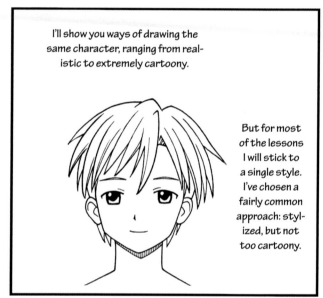

I'll show you ways of drawing the same character, ranging from realistic to extremely cartoony.

But for most of the lessons I will stick to a single style. I've chosen a fairly common approach: stylized, but not too cartoony.

As you advance in your abilities, you'll want to try other styles. Consider my lessons a starting point.

Time to sharpen your pencils! The lessons are about to begin.

# Choosing Your Style

Note that each head has as its base a circle at the top with intersecting lines in it. This is a great starting point because it's the same every time. The dead center of a circle doesn't change. Once I have the circle, I add intersecting lines. The rest of the face can be built once you see where the lines should fall to produce the type of face you want.

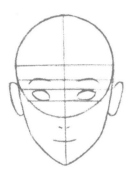
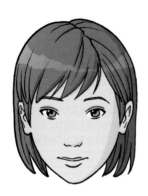

### Realistic

This face falls so close to true human anatomy it almost doesn't qualify as manga. On a real human face, the eyes are much smaller, and the nose and mouth far more prominent. The ears are at the same level as the eyes.

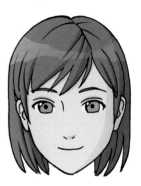
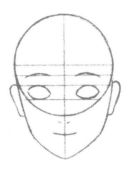

### Slightly Cartoony

This facial construction is what you might see in boy's action-oriented manga. The eyes get bigger, and the nose and mouth become less detailed. However, the distance between the eyes and the tip of the nose is still pretty close to real anatomy.

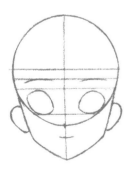
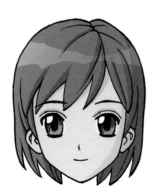

### Very Cartoony

In this approach the enlarged eyes result in a different relationship with the rest of the features, and the ears are now level with the nose.

I can't stress enough how important it is to replicate this balance if you want to do this style. Manga fans are a discerning bunch. If you get it wrong, they'll see it and let you know!

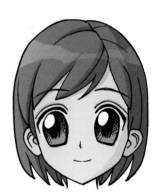
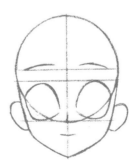

### Extremely Cartoony

We're reaching the far edge of the spectrum here, but have not pushed it to the limit. This style lends itself more to the shojo romance genre, where expressive eyes are what it's about. Looking at the circle of the blue-print drawing, you'll find the eyebrows are very high on this head.

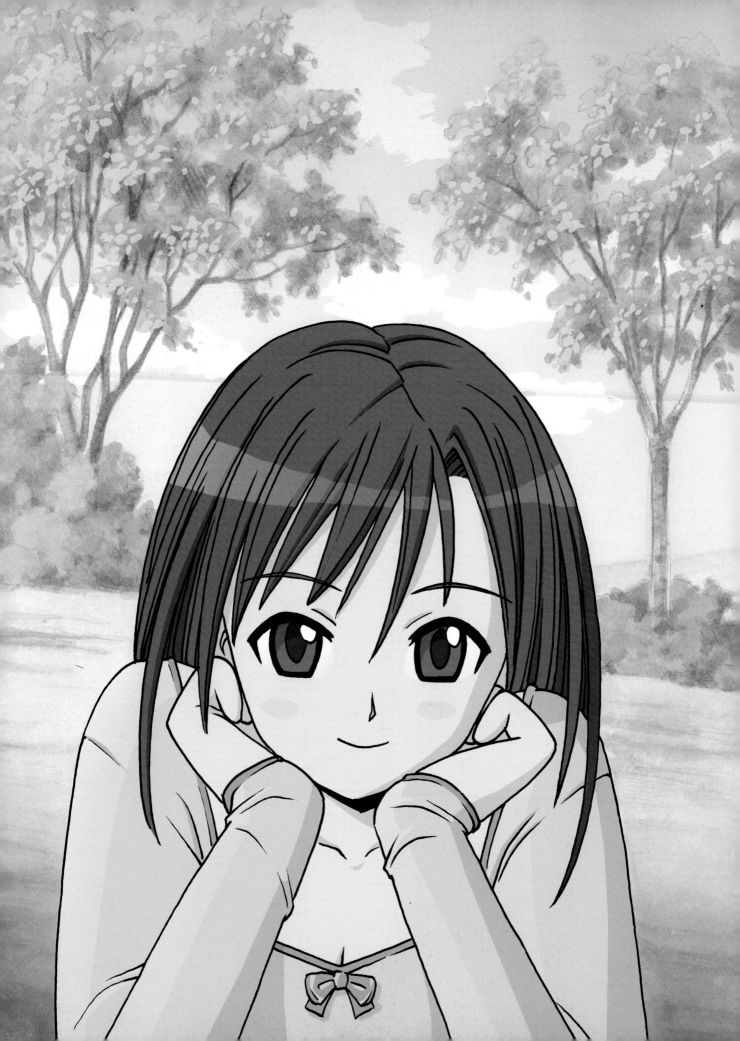

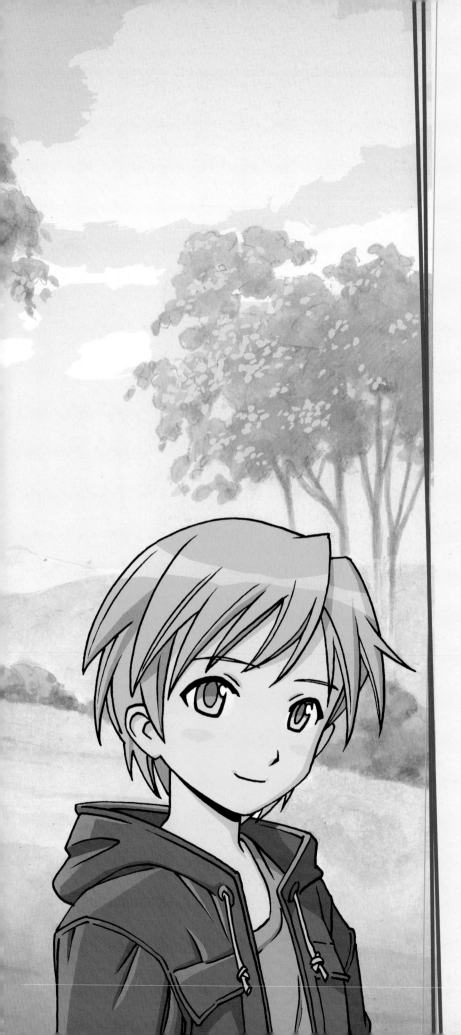

# Heads and Faces

The face is far and away the most important aspect of manga drawing. If you're great at drawing backgrounds and clothing but are getting the faces wrong, you'll have a hard time getting your art accepted by manga fans.

Happily, drawing a manga face well is within the grasp of even the most inexperienced artist, provided you are willing to start with a few basic guidelines.

# Female Front View

Some artists draw faces that are nearly photographic, others draw characters with eyes the size of dinner plates. In this lesson you'll learn to draw a face structure somewhere between those two extremes: Recognizably "manga" in its approach, but not too over-the-top.

The emphasis is on getting the head shape right and placing the eyes, nose and mouth in their proper locations.

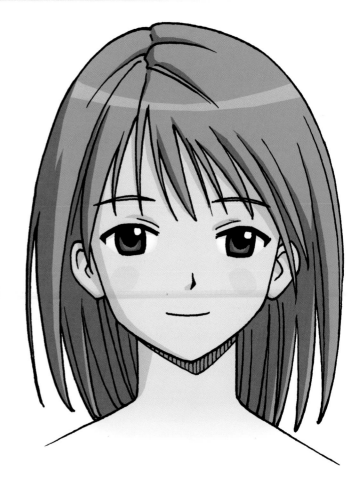

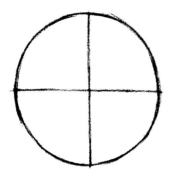

### 1 Draw Your Circle
Draw a rough circle divided by a vertical line and a horizontal line. The vertical line is to help you place the nose. The horizontal line will help place the eyebrows and eyes.

To evenly space the three lines, draw the middle line first, dividing the space in half. Then draw the other two lines, dividing the space into quarters.

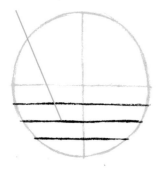

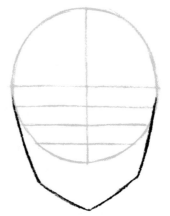

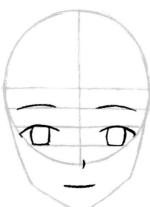

### 2 Mark the Feature Lines
Divide the lower half of the circle into four equal sections with three lines. The first line will be for the eyebrows. The second will be for the upper eyelashes of the eyes. The third will be for the irises.

### 3 Outline the Jaw
Add lines for the jaw. Focus on the angles of each line and the shape created between them and the circle. The distance between the bottom of the circle and the chin is about a quarter of the circle's diameter.

### 4 Place the Features
The upper eyelash lines touch the edge of the circle on each side. Keep the width of one eye blank between the eyes. This blank space is as important as the eye shapes.

The nose rests on the bottom of the circle. Place it exactly in the center if you prefer. The mouth is midway between the circle and the tip of the jaw.

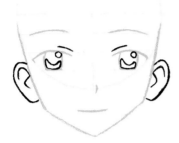

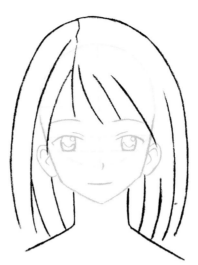

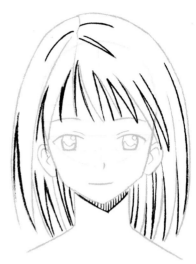

## 5 Draw the Ears and Eyes

The top of the ear is about as high as the middle of each eye. The bottom is not quite as far down as the line of the mouth.

The line above each eye indicate the fold of the upper eyelid. Many artists place these lines above the inside corners of each eye, not stretching all the way across as they do in real life.

## 6 Form the Hair and Neck

Add lines for the hair, neck and shoulders. The upper line of the hair is a fair distance above the circle, nearly a quarter of the entire diameter. Manga heads tend to be fairly top heavy this way, which contributes to the youthful look of the characters.

## 7 Fine-Tune

Indicate the shadow beneath her chin and add details to her hair. The hair lines curve following the shape of the head.

## 8 Finish the Drawing

Ink all the lines you want to keep and erase the rough guidelines once the ink dries completely. The finished drawing can be enhanced with gray tones or given the full color treatment.

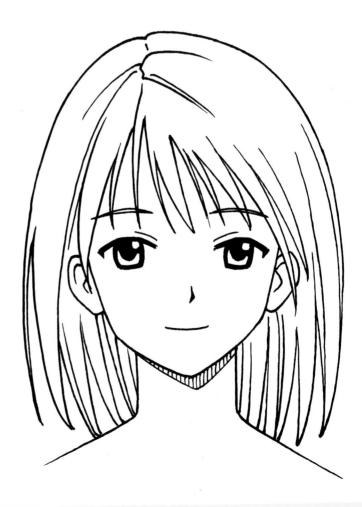

# Female Three-Quarter View

The most important way of drawing a manga face is not the front view but the three-quarter view. After all, in an actual manga story it's uncommon to have a character speak straight to the reader. More often the character speaks to another character within the story and will be slightly turned to one side.

Fortunately it's not that difficult and takes just a little practice to draw like a pro!

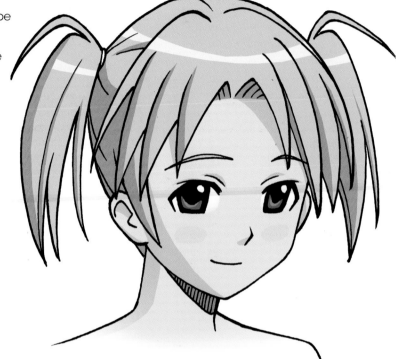

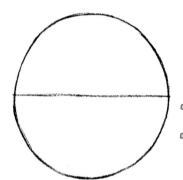

**1 Draw Your Circle**
Divide it with a horizontal line.

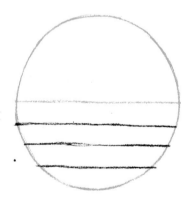

**2 Mark the Feature Lines**
Divide the lower half of the circle into four equal sections by adding three more lines.

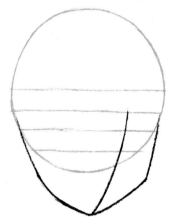

**3 Outline the Jaw**
Add a gently curving vertical line that starts at the chin and heads a little off to one side. Focus on these lines and the shapes they make in relation to the circle. The line should stop at the brow line, second from the top.

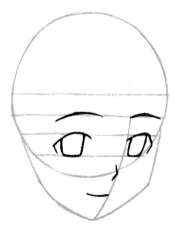

**4 Place the Features**
Draw the eyes, eyebrows, nose, and mouth. All four of these facial features touch the curving line at various intersections. Be careful placing the left eye. The blank spaces surrounding it are as important as the eye itself.

Note that in the three-quarter view her right eyebrow is not directly above the eye, but a little off to one side.

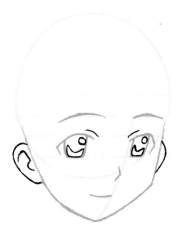

**5 Draw the Ears and Eyes**
Create a highlight near the top and a curving shape at the bottom of each iris. Also add short curving lines just above the inside corner of each eye.

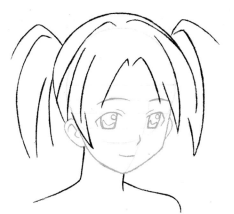

**6 Form the Hair and Neck**
Draw the neck so that it meets the intersection of the ear and cheek on one side, and the tip of the chin on the other.
Begin sketching out the hair.

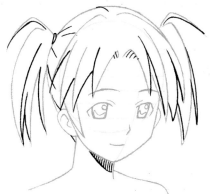

**7 Fine-Tune**
Add shape to the hair with additional lines. An extra stray hair or two at the top of her pigtails can add a natural look. Indicating a shadow beneath the chin helps the picture look three-dimensional.

**8 Finish It**
We're nearly done! Grab your pens and ink all the final lines. Let it dry then erase the guidelines to leave a polished, professional finish.

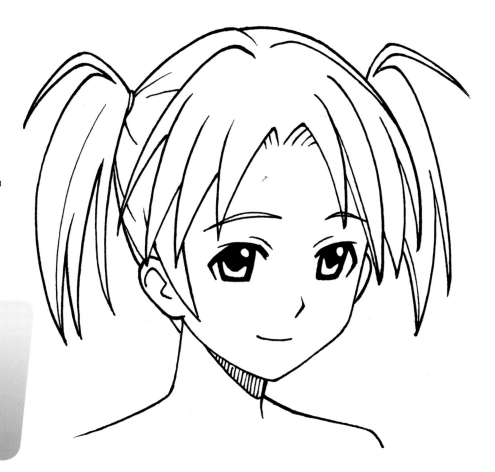

**Happy Hairstyling**

Of course, there's no need to make your character have the same hairstyle you see here. For more hairstyle ideas, see "20 Female Hairstyles" later in this chapter.

# Male Front View

In the American and European style comic book tradition, male and female characters are drawn in dramatically different ways. Superman's face is much more square-jawed than Lois Lane's, and if you were to reverse the two facial structures the results would be bizarre indeed! This is not the case with the majority of manga characters, where the differences between male and female facial structures are often negligible. We are left to tell which is which mainly by the hair and just a hint of a difference in the eyes.

This is good news for aspiring manga artists. If you can draw female faces well, you're just a few line adjustments away from drawing males. In fact, the first five steps are almost exactly the same!

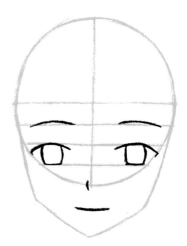

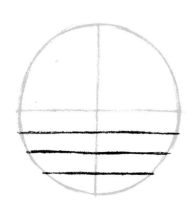

**1 Draw Your Circle**
Divide with horizontal and vertical lines.

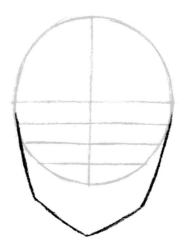

**2 Mark the Feature Lines**
Divide the lower half of the circle into four equal sections by adding three more lines.

**3 Outline the Jaw**
Focus on the angles of each line and the shape that is created between them and the circle. The distance between the bottom of the circle and the tip of the jaw is about a quarter of the circle's diameter.

**4 Place the Features**
The upper eyelash lines touch the edge of the circle on each side. Keep a blank space the width of one eye between the eyes.

The nose rests on the bottom of the circle. Place it in the center if you prefer.

The mouth is midway between the circle and the tip of the jaw.

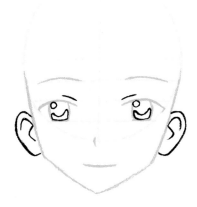

**5** **Draw the Ears and Eyes**
The top of the ear starts at the middle of each eye. The bottom is just above the line of the mouth.

The lines over the eyelids indicate folds. Place these lines above the inside corner of each eye. The small circles in each iris are highlights and make the eyes look shiny.

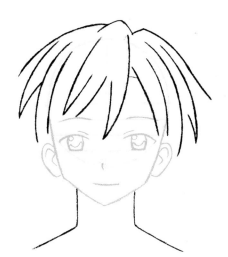

**6** **Add the Hair and Neckline**
Not all boys have short hair, but a comparatively short haircut makes your character readable as a male.

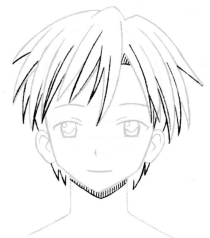

**7** **Fine-Tune**
Manga artists often structure the hair as I have here with the strands on the forehead parting so they don't obstruct the eyes. Add an indication of shadow beneath the chin and you're ready to ink.

**8** **Finish It**
The lines of the upper eyelashes are a little more thin than in the female version, a small but crucial detail because it is the only facial difference between the two.

Let the ink dry completely, then erase. Leave as is, shade or color!

**Hair Raising**
You can try one of the "20 Male Hairstyles" later in this chapter, too!

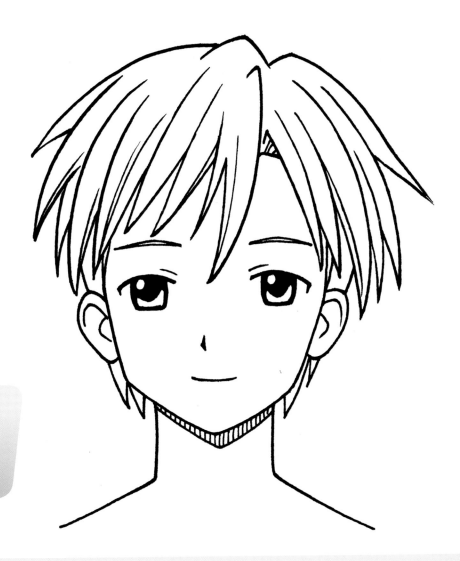

# Male Profile View

Drawing a realistic face in profile presents unique challenges that can trip up even the most experienced illustrators. A manga face in profile is considerably more streamlined and simplified, but nevertheless requires special effort to master. The distances between the various facial features must be learned, of course, but added to this is the challenge of drawing the contours of the forehead, nose and mouth.

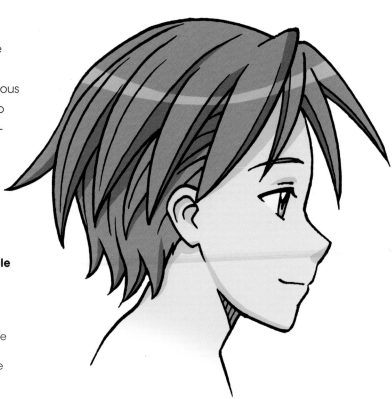

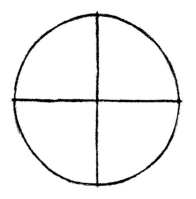

**Draw Your Circle**
Divide the circle by vertical and horizontal lines. This time the vertical line is there to help you place the ear. The horizontal line will help you place the eyebrow.

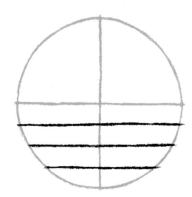

**Mark the Feature Lines**
Divide the lower half of the circle into four equal sections by adding three more lines.

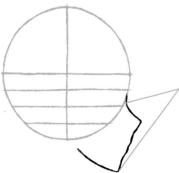

Compare the tip of the chin to the point where the line begins to curve off from the forehead. The chin is a touch farther left.

**Outline the Jaw**
Begin with a line that curves off from the circle between the 2nd and 3rd lines. The angle as it reaches the tip of the nose is just a touch higher than the bottom horizontal line. From there draw a line down to the chin with small bumps for the lips midway down.

Finally, add the curving line of the jaw, making it point back toward the bottom of the vertical line, without quite touching it.

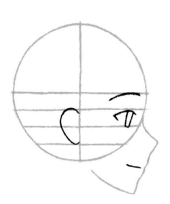

**Place the Features**
Add the eye, eyebrow, ear and mouth. The eye rests between the 2nd and 3rd horizontal line's, and is close to the edge of the circle, but doesn't touch it.

The ear sits between the 2nd and 4th horizontal lines and is flat against the vertical line. The mouth is close to the midway point between the nose and chin.

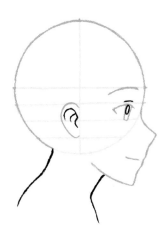

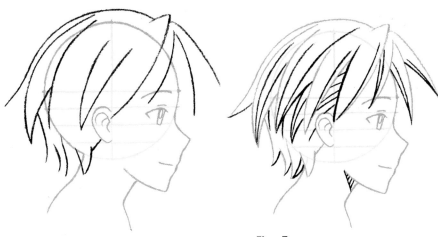

**5 Add Details**

Join the neck to the head a touch to the left of the ear on the back of the neck. The line of the throat starts halfway between the tip of chin and the bottom of the vertical line.

Add pupils to the eyes and curves to the inside of the ear.

**6 Add the Hair**

Sketch in a rough hairstyle with a few lines.

**7 Fine-Tune**

Add individual strands of hair and a shadow beneath the chin.

**8 Finish It**

Carefully ink the drawing, taking care not to ink any of the rough guidelines. Let it dry, then erase the pencil lines.

The finished drawing can be left as is, enhanced with gray tones or given the full color treatment.

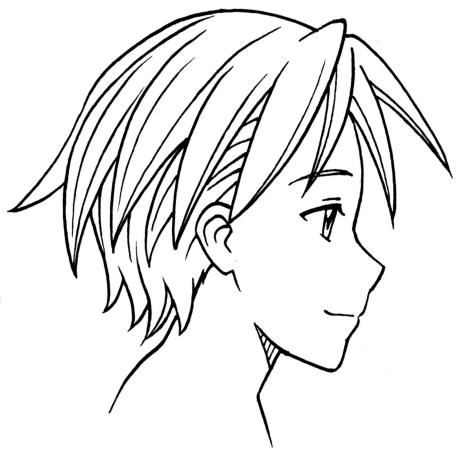

# 20 Female Hairstyles

Knowing how to draw hairstyles is absolutely crucial in manga. With facial features and sometimes even school uniforms rendering characters all but indistinguishable from one another, the hairstyle may be the reader's only means of telling one kid from another. These pages show twenty ways to draw manga hair for female characters.

**Long Hair**
A long, straight haircut can make a character appear more worldly.

**Short Hair**
A short haircut is often used to convey innocence and a childlike nature.

**Curly Hair**
Manga artists tend to avoid the impression of frizzy hair and render curls in the form of waves or ringlets.

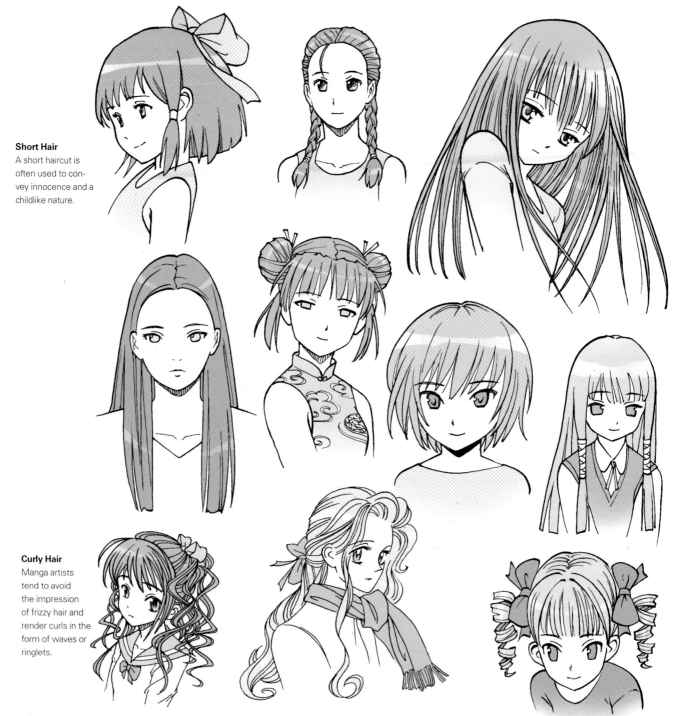

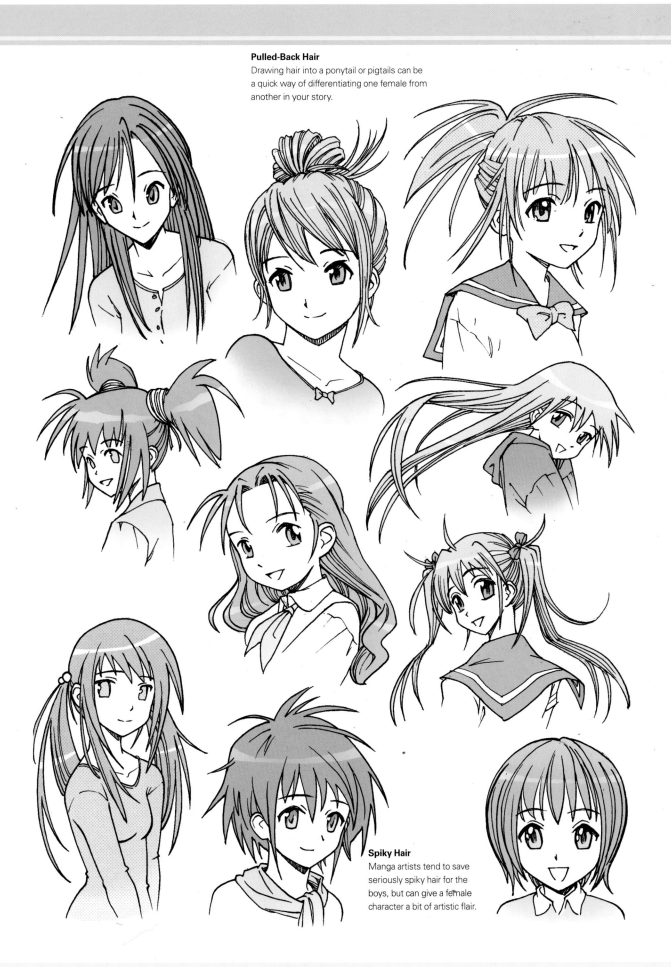

**Pulled-Back Hair**
Drawing hair into a ponytail or pigtails can be a quick way of differentiating one female from another in your story.

**Spiky Hair**
Manga artists tend to save seriously spiky hair for the boys, but can give a female character a bit of artistic flair.

# 20 Male Hairstyles

Male hairstyles are somewhat more limited in variety than for females'. Still, creative artists find ways of coiffing manga guys in distinctive ways that make them instantly recognizable.

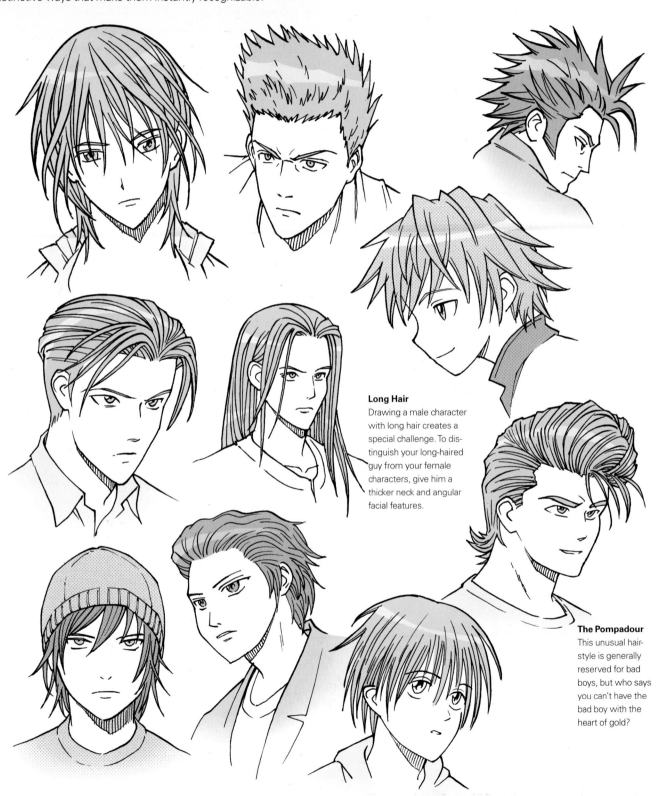

**Long Hair**
Drawing a male character with long hair creates a special challenge. To distinguish your long-haired guy from your female characters, give him a thicker neck and angular facial features.

**The Pompadour**
This unusual hairstyle is generally reserved for bad boys, but who says you can't have the bad boy with the heart of gold?

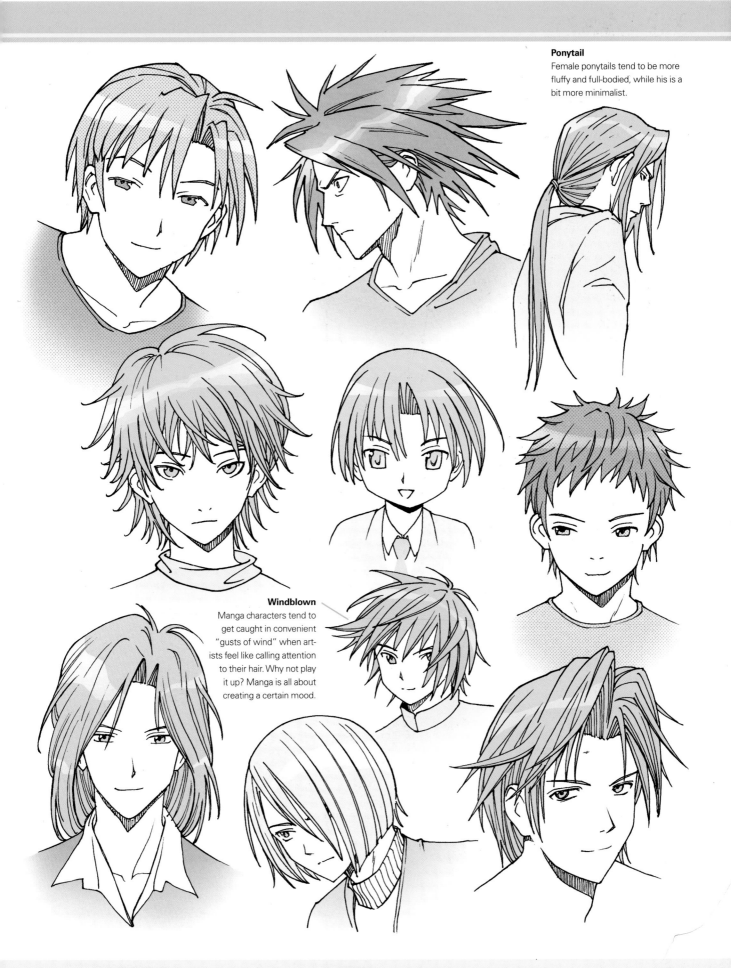

**Ponytail**
Female ponytails tend to be more fluffy and full-bodied, while his is a bit more minimalist.

**Windblown**
Manga characters tend to get caught in convenient "gusts of wind" when artists feel like calling attention to their hair. Why not play it up? Manga is all about creating a certain mood.

# Adult Front View

Manga stories tend to be dominated by youthful characters in high school or fantasy characters who are vaguely teen-aged. Still, that doesn't mean you'll never need to draw an older character.

Manga artists tend to regard the older characters as inhabiting a different world in terms of the way they are drawn. They often bear little resemblance to the kids at the heart of the story. Not only is the facial structure quite different, but there are all those wrinkles to contend with.

But never fear: given the right guidelines, drawing an older character need be no more difficult than drawing the young protagonists.

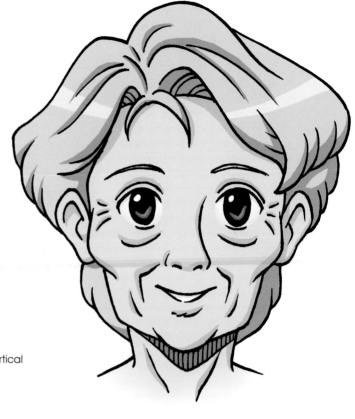

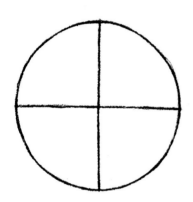

**Draw Your Circle**
Divide the circle by a vertical and horizontal line.

**Mark the Feature Lines**
Divide the lower half of the circle into four equal sections by adding three more lines.

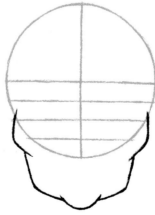

**Outline the Cheeks and Jaw**
The shape is considerably more complicated than that of the youthful face, so extra attention must be paid to get the lines right. Note the distance of the tip of the chin from the bottom of the circle: It's roughly equal to a third of the diameter of the entire circle.

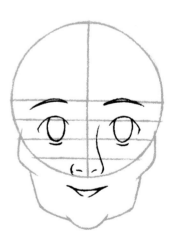

**Place the Features**
Note that the eyebrows and eyes are a full line higher on the face than in younger characters.

Probably the biggest difference between young and old manga characters is the depiction of the nose. It is much more fully rendered for older characters.

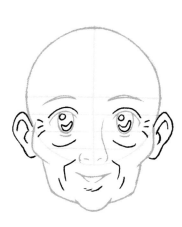

### 5 Add Details

Time to add ears, eye details and wrinkles. Note that simple crow's-feet and a single line beneath each eye are enough to convey the age of the character.

Lines on either side of the mouth also add age.

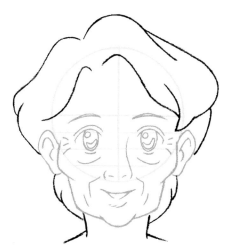

### 6 Form the Hair and Neck

Sketch the neck lines in and add the basic lines of the hair. A larger forehead is typical. The hairstyles of older characters are generally less flashy than those of younger characters.

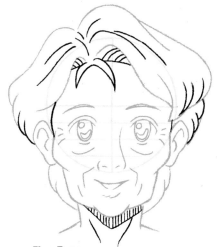

### 7 Fine-Tune

Add a shadow beneath the chin and more lines to define the hair. An elderly character will also have a line or two delineating the wrinkles of the neck.

### 8 Finish It

Ink the lines and let it dry, then erase the guidelines. You can keep it black and white, add some gray tones or color..

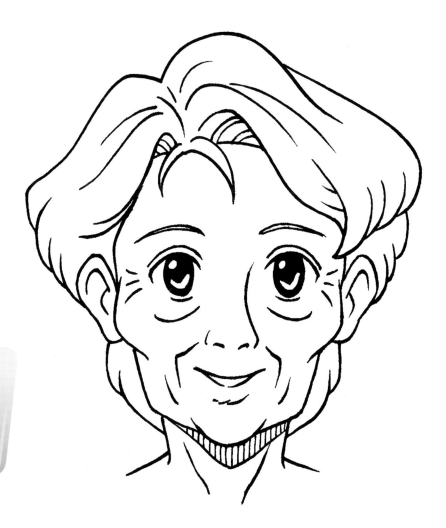

### Less Is More

Adding lines to the sides of a character's mouth ages them. Be careful with details for any character you want to look youthful.

# Adult Three-Quarter View

Just because you're drawing an older character doesn't mean they have to look like they're ready for the retirement home. Sometimes you want to draw someone who simply looks slightly older than your teenaged protagonist.

With these characters you can't rely on wrinkles and gray hair to show their age, so it's going to be more about the facial structure. Most manga artists opt to depict grown-up characters with faces that are considerably closer to real human anatomy. This means that starting out with proper guidelines is more important than ever.

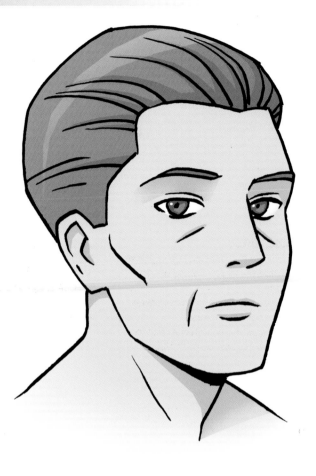

**1 Draw Your Circle**
Divide the circle by vertical and horizontal lines.

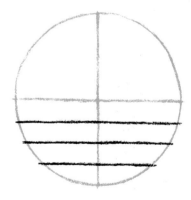

**2 Mark the Feature Lines**
Divide the lower half of the circle into four equal sections by adding three more lines.

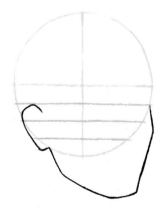

**3 Outline the Jaw and Ear**
The upper cheek begins where the second horizontal line intersects the circle. Observe the unusual white shape created between the edge of the circle and the lines of the jaw.

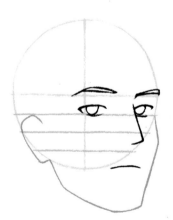

**4 Place the Features**
Add the eyebrows, eyes, nose and mouth. The iris of the eye on the left touches the vertical line. Use that to place the left eyebrow.

The tip of the nose falls between the third and fourth horizontal lines on the edge of the circle.

Place the mouth a little less than halfway between the chin and nose, just outside the edge of the circle.

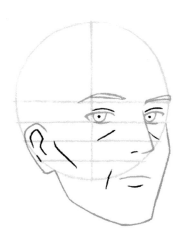

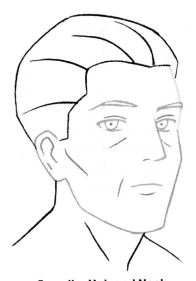

### 5 Add Details

One line below each eye suggests maturity without making him look grandfatherly.

Add lines defining the cheek bones and the curves of the ears.

A line below the mouth defines the lips while one on the side adds maturity.

### 6 Form the Hair and Neck

The lines of the hair curve up and back to follow the surface of the head. A single line on the neck is not only anatomically accurate but also adds a few years to the character.

### 7 Fine-Tune

Add a few more lines to the hair and a shadow beneath the chin. I've made my character clean shaven, but many manga artists give fatherly characters a mustache or beard to separate them from the youthful protagonists.

### 8 Finish It

Ink the lines and let it dry, then erase the guidelines. You can keep it black and white, or add some gray tones or color.

Find a bonus demonstration of an older character's profile online at **impact-books.com/mastering-manga.**

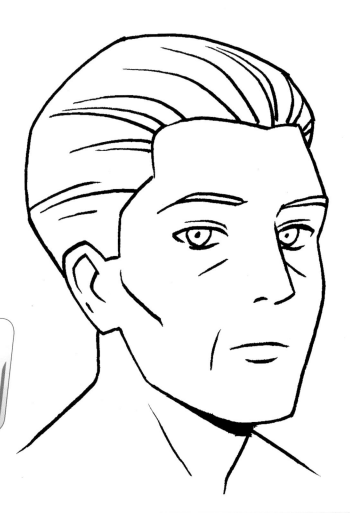

# Fuller-Figured Character Front View

Just as older characters rarely get the limelight, fuller-figured characters are generally sidelined or left out. But this doesn't mean you'll never want to include such characters in your stories.

Cartoonists have long rendered fuller-figured characters in an exaggerated, humorous way, but that is not what I'm interested in. I'd like to present a respectful way of depicting fuller-figured characters, allowing them to be among the main characters of a story rather than forcing them into the background as comic relief.

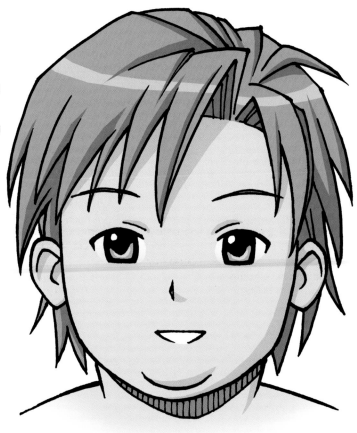

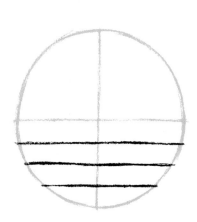

**Draw Your Circle**
Divide the circle by vertical and horizontal lines.

**Mark the Feature Lines**
Divide the lower half of the circle into four equal sections by adding three more lines.

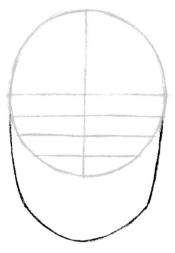

**Outline the Jaw**
This is the main difference between the standard manga face and a fuller face. Instead of a point, the chin curves at the bottom.

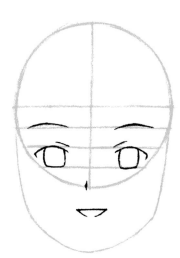

**Place the Features**
Add the eyes, eyebrows, nose and mouth. The locations of all these facial features are more or less identical to their locations on the standard manga face.

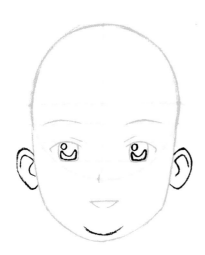 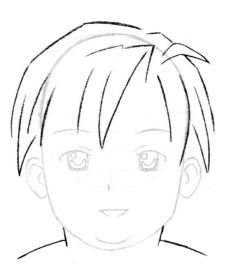 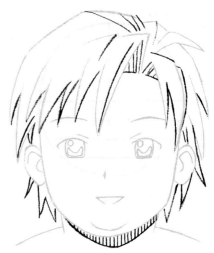

**5** **Add Details**
Add the ears, details to the eyes and a double chin line near the bottom. Not all fuller-figured people have double chins, but it can be a good way to define your character.

**6** **Form the Hair and Neck**
The neck is considerably wider than that of the standard manga character.

**7** **Fine-Tune**
Add an indication of shadow beneath the chin and more details to the hair.

**8** **Finish It**
Ink the lines, let it dry, then erase guidelines. You can keep it black and white, and add some gray tones or color.

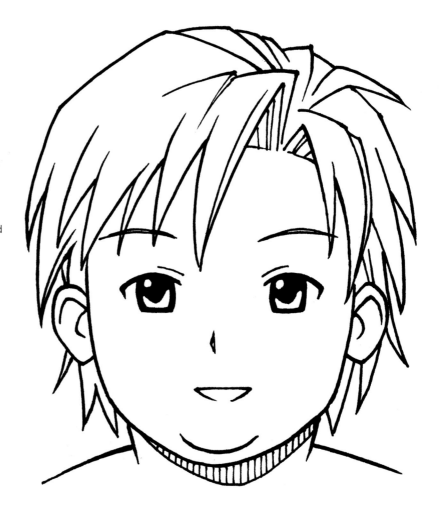

# Fuller-Figured Character ¾ View

The three-quarter view is the one we see in manga again and again. There's just something more natural and appealing about this point of view.

In essence it is only the shape of the jaw, not the facial features, that changes in comparison to the earlier three-quarter view lesson. It's a tricky line to draw though. At what point does the double chin become comical and over-done? I advise approaching it with subtlety.

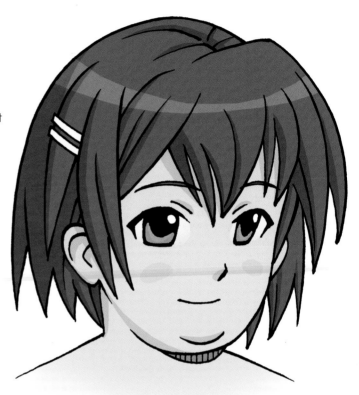

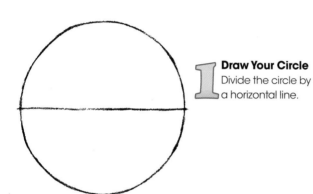

**1** **Draw Your Circle**
Divide the circle by a horizontal line.

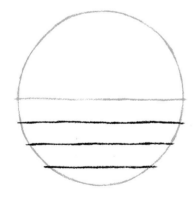

**2** **Mark the Feature Lines**
Divide the lower half of the circle into four equal sections by adding three more lines.

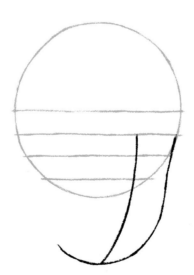

**3** **Outline the Jaw**
Like the front view, this chin curves. Draw a second curving line from the chin up to the second of the four horizontal lines. Take care to maintain the distance between this line and the outside line.

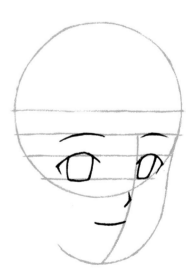

**4** **Place the Features**
Add the eyes, eyebrows, nose and mouth. The locations of all these facial features are more or less identical to their locations on the standard manga face, but the distance between the mouth and the chin line is markedly different.

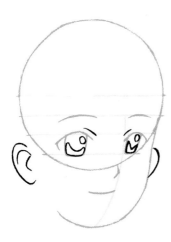

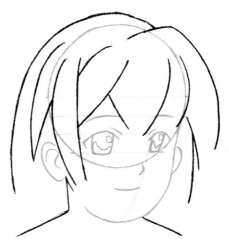

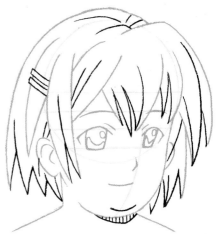

**5** **Add Details**
Add the ears and details to the eyes. The highlights will make the eyes shiny. The little dash above each eye denotes the folding of the eyelid.

**6** **Form the Hair and Neck**
The line of the neck begins at the base of the ear, and there is also a short line here suggesting the edge of the cheek. This hairstyle is, of course, up to you..

**7** **Fine-Tune**
Add an indication of shadow beneath the chin and more details to the hair.

**8** **Finish It**
Ink the lines and let it dry, then erase the guidelines. You can keep it black and white, and add some gray tones or color.

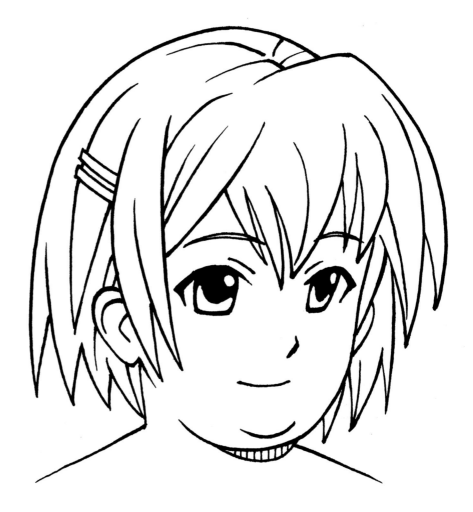

# Child Front View

Youthful manga characters intended to be teens (or even adults) are often drawn with oversized eyes that make them reminiscent of children. So what do you do when the character you're drawing is supposed to be a *real* child?

Relax. The main thing is to push things a little further than you do with your teen characters in terms of the eyes, cheeks and hair.

As always, guidelines will give you your best chance of drawing the character consistently from one panel to the next.

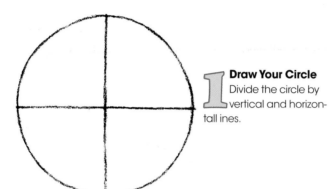

**Draw Your Circle**
Divide the circle by vertical and horizontal lines.

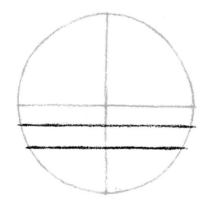

**Mark the Feature Lines**
Divide the lower half of the circle into three sections by adding two additional horizontal lines. The first of these two lines will be for placing the eyebrows. The second will be for the upper eyelashes.

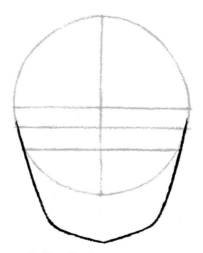

**Outline the Jaw**
This is one of the big differences between the standard teen face and a child's face. The jaw still comes to a point, but the cheeks are squared off to create that baby-faced look. Replicate the angles on each side, connecting the jawline to the skull at the middle line.

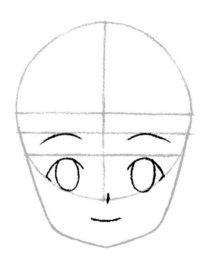

**Place the Features**
Add the eyes, eyebrows, nose and mouth. The key difference here is the space occupied by the eyes. This tyke's eyes are nearly twice as big. The mouth is halfway between the circle and the tip of the chin.

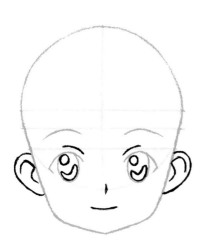

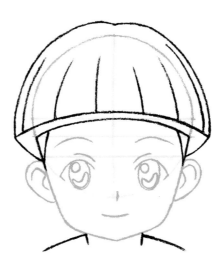

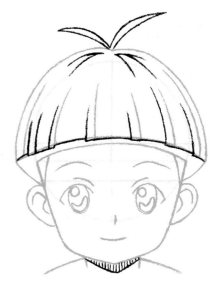

### 5 Add Details
Draw the ears and fill in the eyes. All of this is much the same as you'd do with a teen character, though you could experiment with making the ears a bit larger if you want to add to the cuteness of the character.

### 6 Form the Hair and Neck
This bowl cut is a bit on the cartoonish side. The reader will see this character as a child from a mile away, but you can give him a more natural 'do if you're so inclined.

### 7 Fine-Tune
Speaking of cartoonish, I decided to add a couple of stray hairs popping off the top of the head. Again, ignore this part if you think it's ridiculous. (It is.) Add a little shadow beneath the chin.

### 8 Finish It
Ink the lines and let it dry, then erase the guidelines. You can keep it black and white, or add some gray tones or color.

(Admit it: those stray hairs make the drawing!)

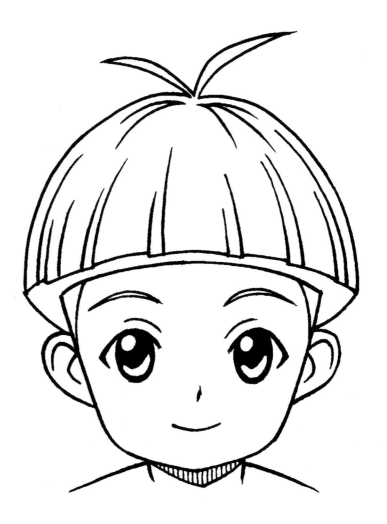

# Child Profile View

Drawing characters in profile can be tricky regardless of what kind of characters they are. Still, you'll need to draw all your characters in profile at one point or another, and the child's facial proportions make profiles a new challenge from their older siblings.

How do we get it right? How else? Guidelines!

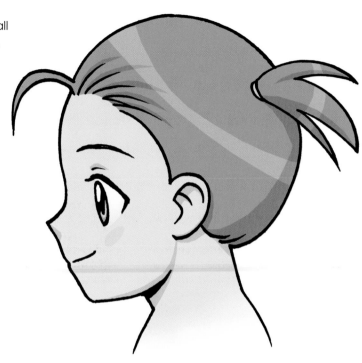

**1 Draw Your Circle**
Divide the circle by vertical and horizontal lines.

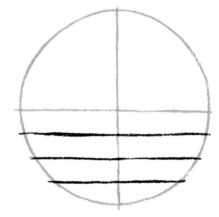

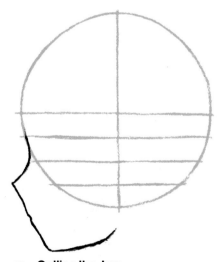

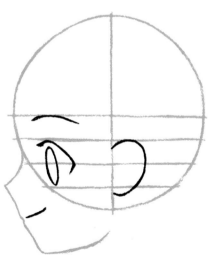

**2 Mark the Feature Lines**
Divide the lower half of the circle into four sections by adding three additional horizontal lines. The first line is for placing the eyebrows. The second is for the upper eyelashes of the eyes.

**3 Outline the Jaw**
Draw a line that gently curves off from the circle near the second of the four lines. It comes to a point at the nose—the same level as the bottom horizontal line. From there bring the line down at an angle. This line is equal to the space between the first and last horizontal lines. From the point of the chin the line curves back toward the bottom of the vertical line. Keep it mostly horizontal, curving up only at the tail end. Don't let it touch the circle.

**4 Place the Features**
Add the eyebrow, eye, mouth and ear. The eyebrow starts roughly above the chin; don't let it touch the circle. The mouth is halfway between the tip of the nose and chin. The ear connects at the vertical line; the top hits the second horizontal and curves just below the bottom line.

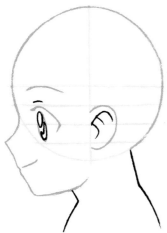

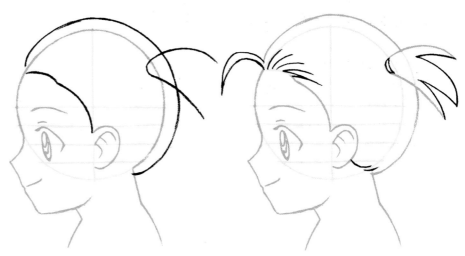

### 5 Add Details and Neck

Fill in the pupil and highlight to the eyes. Add curves to the ear.

Draw the lines of the neck and shoulders. The front of the neck begins about two-thirds of the way along the line of the jaw. The back begins about halfway between the vertical line and the back of her head.

### 6 Form the Hair

It may be cliché, but pigtails are a great way to identify a female child. Of course, your teen character might want to adopt a girlish look, but placing the pigtails high on the head and making her jaw and eyes youthful will keep her little sister looking like the baby of the family.

### 7 Fine-Tune

Add more details to the hair—a stray hair popping off the forehead if you are so inclined (you know me: I can't resist drawing stray hairs).

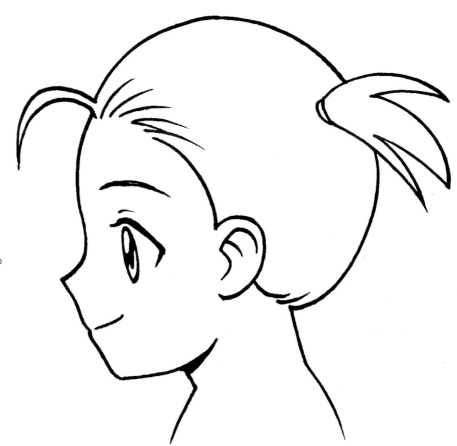

### 8 Finish It

Ink the lines and let it dry, then erase the guidelines. You can keep it black and white and add some gray tones or color.

# 101 Manga Eyes

Nothing says manga like the big, shiny eyes that the style has come to be known for. But every artist comes at it a different way. Find the styles you like, then adapt them for your own characters.

**Semirealistic** Reminiscent of real human anatomy, but still recognizable as manga eyes.

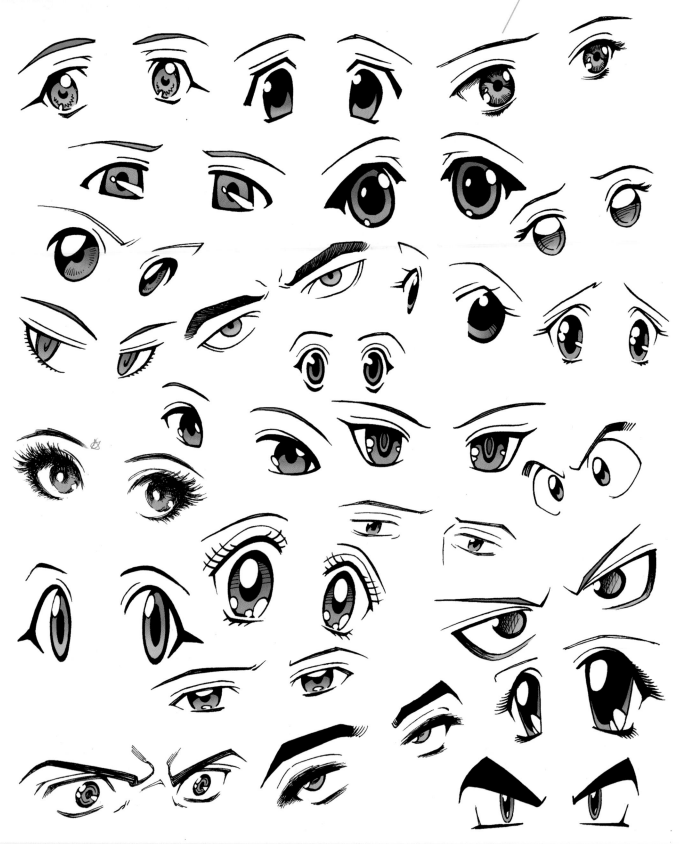

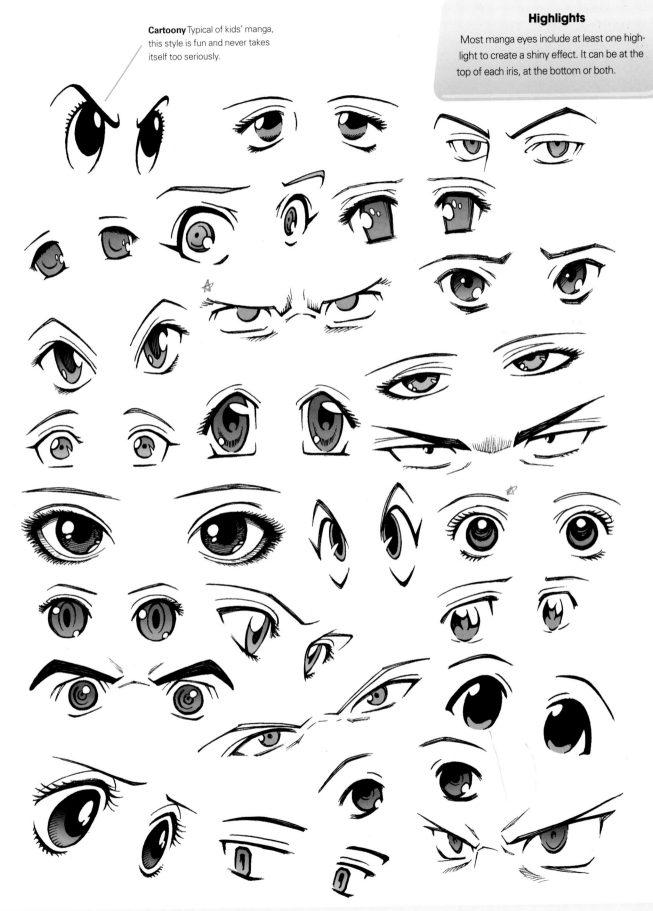

**Cartoony** Typical of kids' manga, this style is fun and never takes itself too seriously.

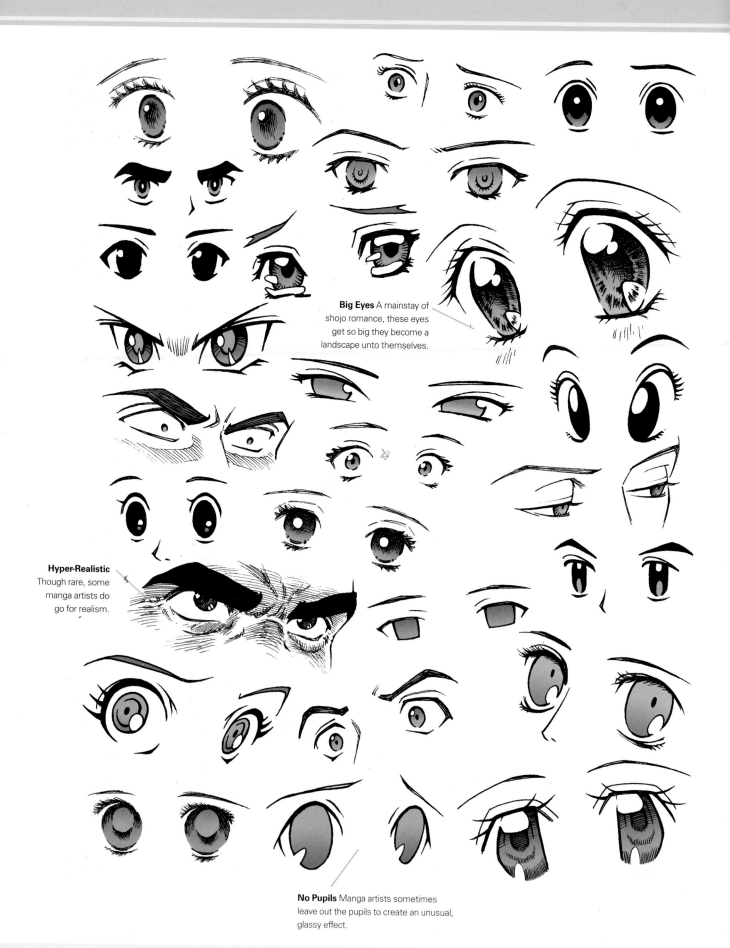

**Big Eyes** A mainstay of shojo romance, these eyes get so big they become a landscape unto themselves.

**Hyper-Realistic** Though rare, some manga artists do go for realism.

**No Pupils** Manga artists sometimes leave out the pupils to create an unusual, glassy effect.

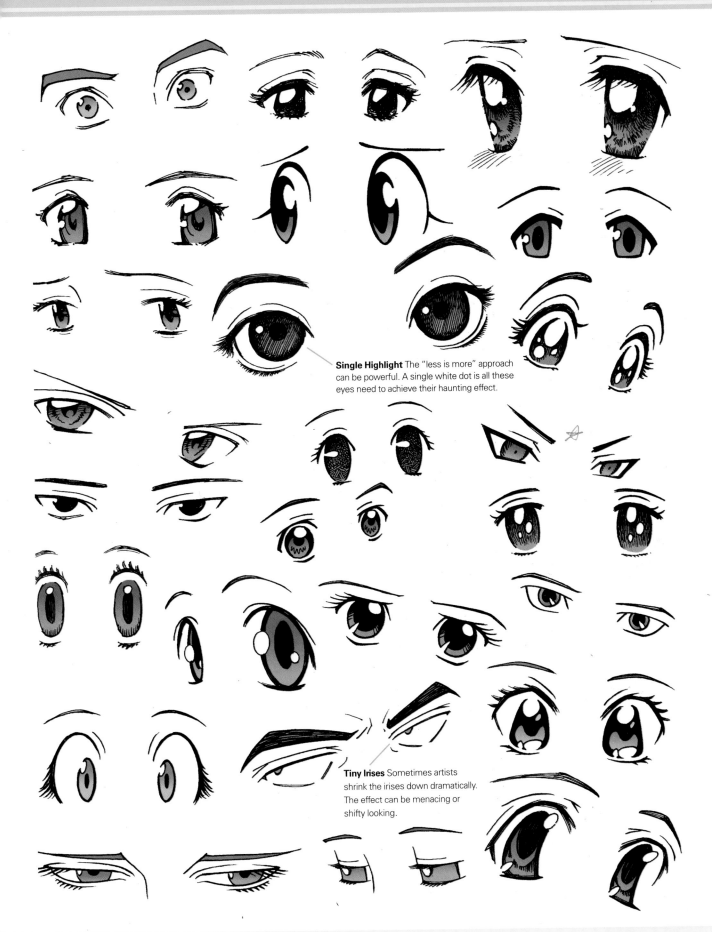

**Single Highlight** The "less is more" approach can be powerful. A single white dot is all these eyes need to achieve their haunting effect.

**Tiny Irises** Sometimes artists shrink the irises down dramatically. The effect can be menacing or shifty looking.

# 12 Common Manga Facial Expressions

Japanese artists have found a way of conveying emotions that is fresh, original and instantly readable to people all over the world. Here are twelve facial expressions manga artists use most.

**Ecstatic Joy**
Pull this one out when simple happiness just won't cut it. The "squeezed shut" eyes are a classic form of manga shorthand for conveying big time happiness. The bottom of the mouth may be left unrendered as a stylistic quirk.

**Cheerful**
The default manga facial expression. The smile is subtle with a small, gentle curve. The bottoms of the eyes are often somewhat flattened, suggesting the cheeks rising to cover the eyes just a touch as the character smiles.

**Concern**
This is a great all-purpose expression to use whenever a character is serious or making an argument. The eyebrows are slightly curved, with just a hint of furrowing to the brow.

**Confusion**
This look of quiet befuddlement is conveyed mainly by the eyebrows. One is angled down as if slightly angry, the other raised as if surprised.

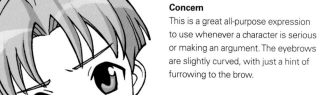

**Sadness or Regret**
The expression is in the eyebrows. They follow a crooked path as they curve toward the center of the forehead. The heavy eyelids and the tiny frown add to the sense of melancholy.

**Boredom**
Flatten the upper eyelashes and tuck the irises at least halfway underneath. The eyebrows float above the eyes at a very neutral angle, and the mouth is small and closed.

**Determination**

A common emotional state in any action oriented manga. Make sure you get the angle and proximity of the eyebrows to the upper eyelashes right. The clenched teeth and the break in the line surrounding the mouth are common in manga faces.

**Anger**

Similar to the look of determination, but with extra crooks on the ends of the eyebrows. The wide-open mouth, the bared teeth, everything comes together to convey her rage.

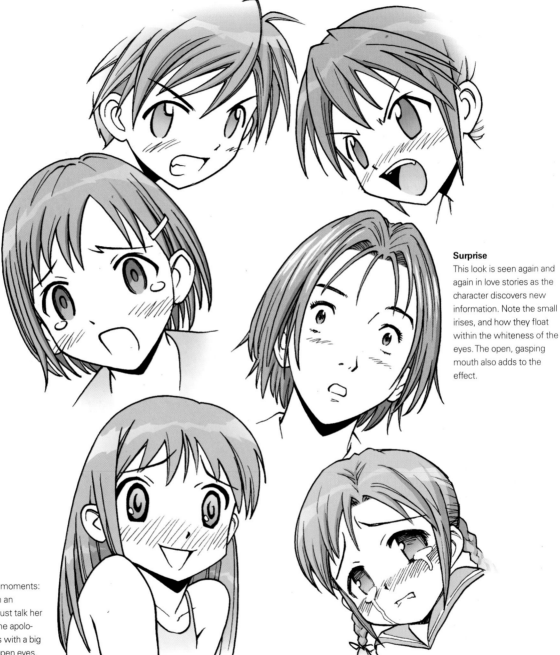

**Distress**

A manga staple, this look comes out at moments of crisis. The eyebrows curve upward and at least one of them ends in a zigzag, signifying a furrowed brow. The irises don't quite touch the upper eyelids, adding to the sense of heightened emotion.

**Surprise**

This look is seen again and again in love stories as the character discovers new information. Note the small irises, and how they float within the whiteness of the eyes. The open, gasping mouth also adds to the effect.

**Embarrassment**

A great one for comedic moments: the character is caught in an awkward position and must talk her way out of it. Combine the apologetic upturned eyebrows with a big smile. Add blush, wide-open eyes, and you've got someone going very red in the face.

**Sadness**

Make the irises large and tuck them well beneath the upper eyelids. Don't overdo the streaming tear. One or two are plenty. The shape of the mouth suggests a quivering lower lip.

# Proportions and Poses

Once you get the faces down, it's time to turn your attention to drawing the manga body. Is it difficult? Absolutely.

But it's nothing that can't be mastered, provided you keep at it. If guidelines are important for drawing the face, they are ten times as important for drawing the body. But where do the guidelines go? Read on, my friends, to learn that and a whole lot more in the chapter ahead.

# Drawing the Human Body

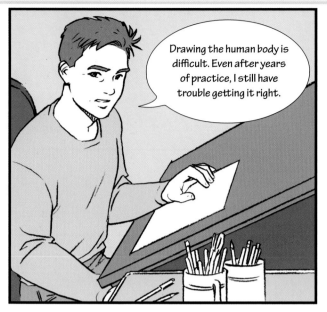

Drawing the human body is difficult. Even after years of practice, I still have trouble getting it right.

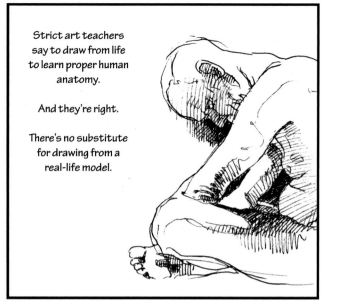

Strict art teachers say to draw from life to learn proper human anatomy.

And they're right.

There's no substitute for drawing from a real-life model.

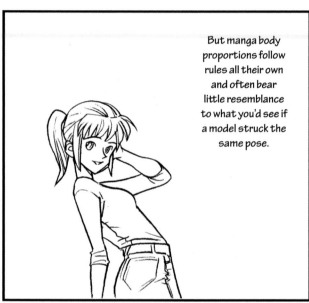

But manga body proportions follow rules all their own and often bear little resemblance to what you'd see if a model struck the same pose.

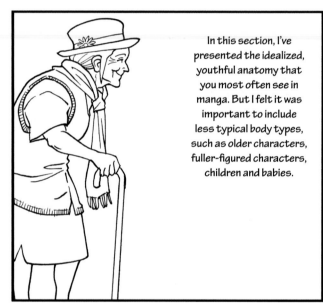

In this section, I've presented the idealized, youthful anatomy that you most often see in manga. But I felt it was important to include less typical body types, such as older characters, fuller-figured characters, children and babies.

And I've added separate sections on drawing hands, feet and folds of clothing, all of which can be especially hard to draw even for the pros. Beginners might think that a real artist is required to draw all this stuff from memory.

Happily, that's not true. If you want to make sure you get things right, look at a reference photo. Professional manga artists depend on it.

# Proportion Tips and Tricks

To get a grip on body proportions start measuring in terms of how many "heads" tall or wide a person is. For example, if you're confused about how long to make the arms, look at this picture to see how many heads "long" they are.

The dotted line shows the difference in proportion between the top and bottom halves.

## Standing

- **Shoulders:** Men are just over two heads wide. Make younger boys narrower and athletic builds wider. Women are under two heads wide. One and a half is cartoony. For a realistic look, go closer to two.

- **Arms:** Two and a half heads from the shoulders to the tips of the fingers.

- **Legs:** Nearly three and a half heads from the top of the thigh to the toes. Stretch this out to make your female character more glamorous.

- **Torso:** Two heads tall from the base of the neck to the top of the inner thigh. The breast line is just over the halfway point.

## Bending and Sitting

- **Upper and lower halves:** The distance from hip to head is slightly longer than from hip to foot and the difference between leg and arm length becomes apparent when side-by-side.

- **Legs:** When seated, the distance from knee to toe is nearly identical to the distance from knee to backside.

- **Arms:** When seated with slack arms, the hand will reach past the thigh.

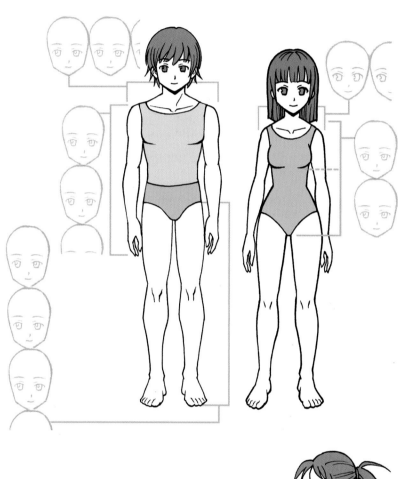

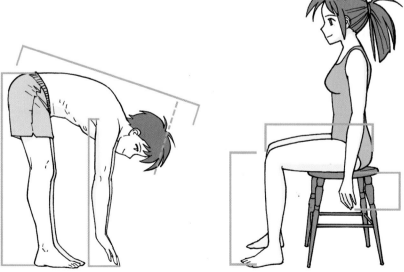

# The Teen Girl

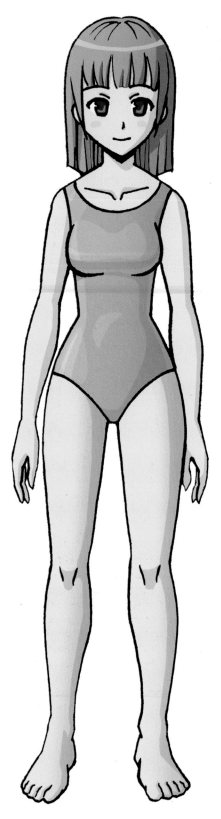

Drawing the human body is always a challenge. If one or two lines aren't in just the right place, the whole drawing will look wrong. Though it takes a little extra time, the only way to guarantee proper body proportions is to make use of extensive preparatory guidelines.

Remember, this girl has her feet firmly planted in manga land and as a result bears little resemblance to a real teenaged girl. If you want to progress in your art beyond the manga style—or even just take your manga drawings to a higher level—you should definitely study true human body proportions.

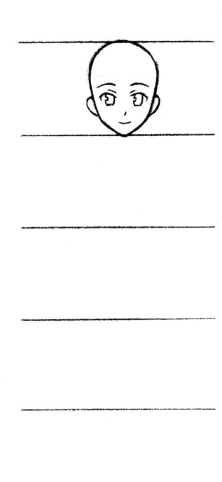

**1 Build Your Frame**
Begin by drawing seven horizontal lines, equally spaced. You'll want them to be at least an inch or more apart to allow for details later on. Draw your character's head (without hair, which will come later) between lines one and two.

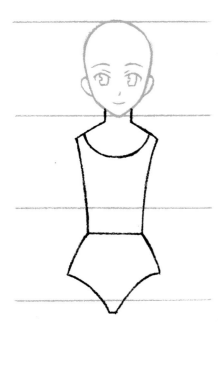

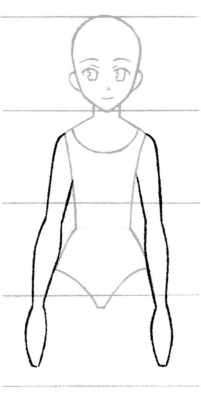

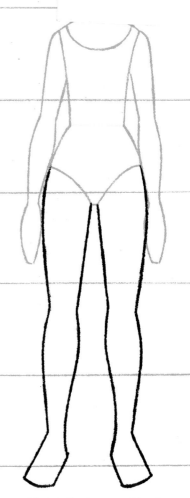

### Create the Torso

Draw the neck, shoulders and trunk. Use the horizontal lines as guides to help you see where the lines go. The shoulders begin just past the second horizontal line. The waist is one third of the way between lines three and four. Don't just replicate the lines; try to get the shapes.

### Add the Arms and Hands

The elbows are just above the waist. The wrists fall just below line four. The width of the each part of the arm is every bit as important as the length. Is your version too wide? Too narrow?

Leave the hands as a shape for now.

### Sketch the Legs and Feet

This is one of the most challenging parts of the drawing. Go slowly, with super-light lines, only darkening them in after you've made sure they're right.

The knees sit below line five while her heels rest on the bottom line. Her toes extend past to look pointed toward the viewer.

Her thighs are wider than calves and make the knees almost twice as wide as the ankles.

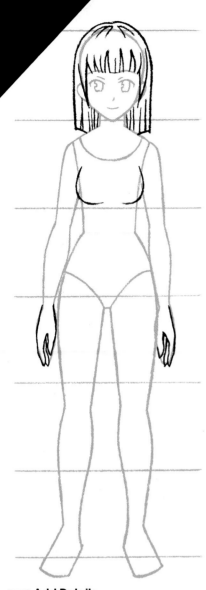

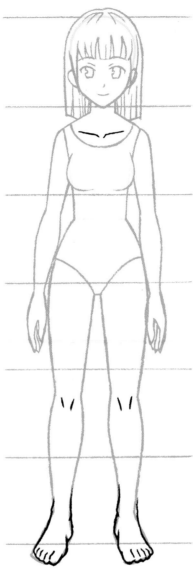

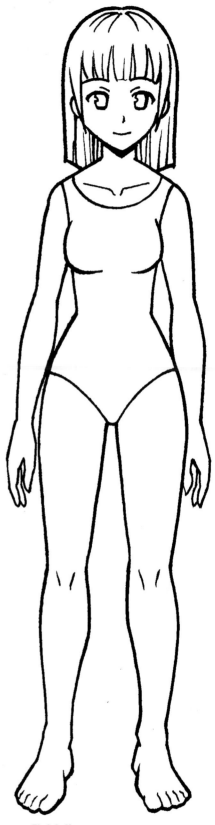

**5 Add Details**
Draw the hair in the style you prefer. The breasts curve just above line three.

Draw the base of the thumb higher than where the fingers begin. Allow them to curl in. Not every finger will be visible from this angle.

**6 Fine-Tune**
Draw a couple of lines to delineate the collarbone and a few short lines to indicate the knees. Define the toes and add a bit of shading to the arches of the feet.

### Thumbs Up!

The hand in this position can be surprisingly difficult to draw. Check out "50 Ways to Draw Hands" to see this pose and others in greater detail.

**7 Finish It**
Ink all the lines except the waistline. Let the ink dry, then erase the guidelines. Leave as is, add some gray tones or color.

You've done it! A teen girl, head to toe, in classic manga proportions.

# Alternative Female Proportion Styles

I always shake a fist when I see someone claiming that there is a single system for drawing manga body proportions. No way. Artists go all over the place in terms of the number of heads tall a character can be. Here are three examples.

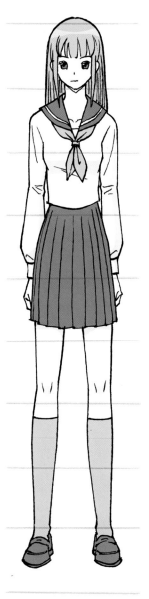

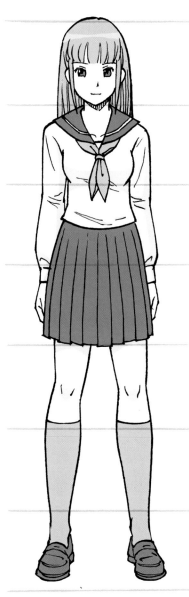

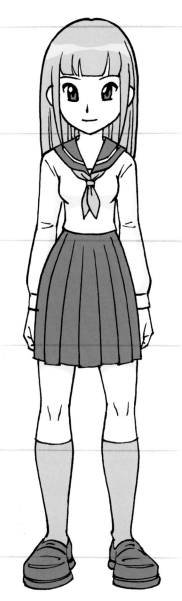

**Super Elongated**

At well over eight heads tall, she may seem like a giant, but she's only average height in a story populated by characters who all look this way. I see this style most often in shojo romance stories.

**Realistic**

Nearly seven heads tall, this girl is not so far from the proportions of a real teen. She is cartoonishly idealized, though, with her waist and torso being considerably shrunken to create a hyper-feminine look.

**Compacted Cartoon**

At just over five heads tall, this girl is starting to slip into chibi territory. And talk about cartoonish! Her waist and torso have been reduced so much she couldn't have lungs. By contrast, the feet are fairly large and the head is competing with the shoulders in terms of width. This approach is generally used for kids' manga, where the accent is on fun and friendly.

# The Teen Boy

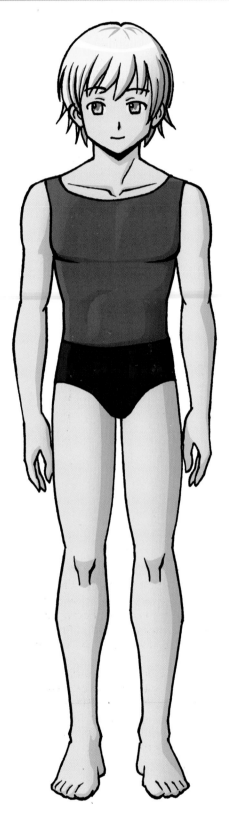

Think you can draw one gender better than another?

If you're able to draw the teen girl, there is absolutely no reason why you won't be just as successful following this lesson. It's all just lines and shapes, after all, and those things don't discriminate between the sexes.

Of course, this is not a real boy we're drawing here. He's our image of what an idealized, fairly buff manga boy looks like. Drawing manga is fun, but you really owe it to yourself to study real human anatomy if you ever get the chance. You won't be sorry!

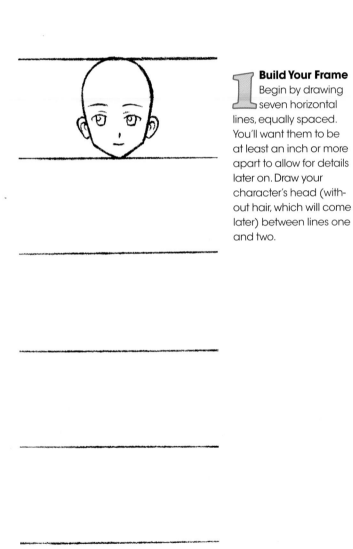

**1 Build Your Frame**
Begin by drawing seven horizontal lines, equally spaced. You'll want them to be at least an inch or more apart to allow for details later on. Draw your character's head (without hair, which will come later) between lines one and two.

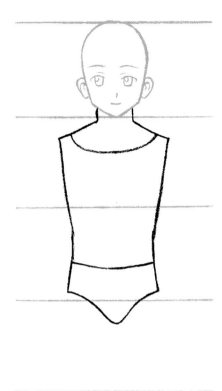

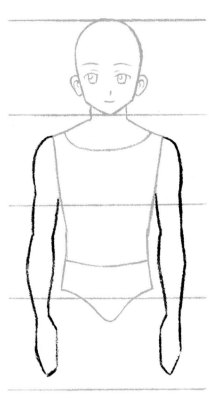

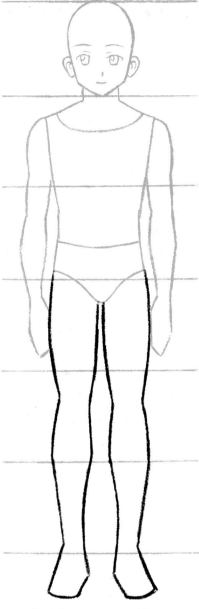

### Create the Torso

Draw the neck, shoulders and trunk. Use the horizontal lines as guides to help you see where the lines go. The shoulders begin just past the second horizontal line. The shoulder area is two heads wide, maybe one shade narrower. The waistline is about a third of the way up between the third and fourth lines.

Draw his neck thicker than a girl's, closer to the jaw.

### Add the Arms and Hands

The elbows are a little closer to line three than four and above the waist. The wrists fall just below line four.

Unlike his female counterpart, this guy's muscles are evident in the contour.

Leave the hands as a shape for now.

### Sketch the Legs and Feet

Men's legs are a bit more angular than women's, so the lines don't need to be so smooth and perfectly placed. Still, go slowly to make sure they're right.

The knees sit closer to line five while his heels rest on line seven. His toes extend past to look pointed toward the viewer.

Make the thighs a good deal wider than the calves. The knees should be a touch wider than the ankles.

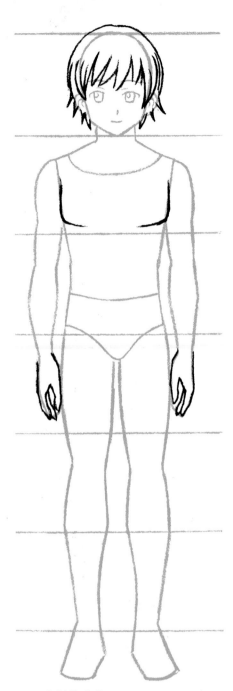

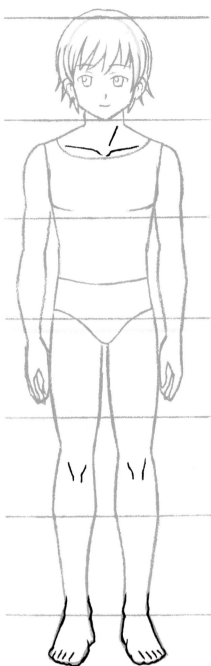

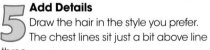

**5 Add Details**

Draw the hair in the style you prefer. The chest lines sit just a bit above line three.

Draw the base of the thumb higher than where the fingers begin. Allow them to curl in slightly toward each other. Not every finger will be visible from this angle.

**6 Fine-Tune**

Draw a few lines to delineate the collarbone and neck, plus a couple of short lines to indicate each kneecap.

Define the toes and shape the feet to add a bit of curve to the arches.

**7 Finish It**

Ink all the lines except the waistline. Let the ink dry, then erase the guidelines. Leave as is or add some gray tones or color.

# Alternative Male Proportion Styles

Manga artists are every bit as fanciful when it comes to the boys. These three examples can be neatly paired with the girls in the Alternative Female Proportion Styles section.

 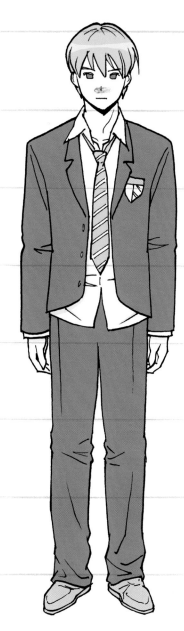 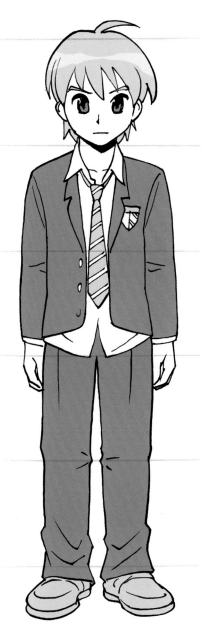

### Super Elongated

This guy is tall at nine heads, but there are artists who will push it even further. Much of the length is in the legs, which are really starting to head into "circus man on stilts" territory. This style occurs most often in shojo romances.

### Realistic

At over seven heads tall, this guy is not too far from the proportions of a real teen. Like his female counterpart, though, he is cartoonishly idealized. The shoulders are broadened to accentuate his masculinity.

### Compact Cartoon

This guy's torso is not altered nearly as much as his female friend's, but his feet have very much the same clodhopper quality and his head is huge.

# The Father Figure

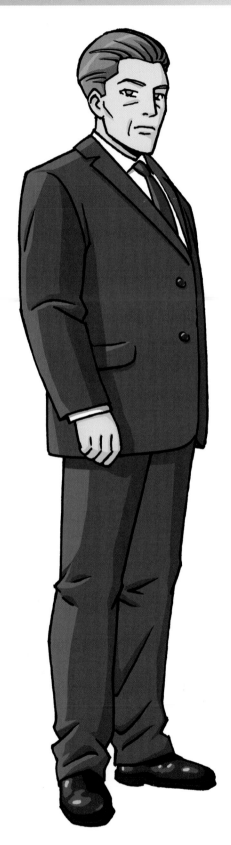

Some manga stories take place in a world populated only by teenaged characters, where adults have seemingly been banished from the scene. Still, even the most youth-obsessed story will have at least a couple representatives of the adult world, and if you're going to draw them properly, you'll need to learn an entirely different system of body proportions.

Manga grown-ups are much closer to real human anatomy. Many of these adult characters have smaller eyes and fully rendered noses that we are more likely to associate with Western comic book characters.

**1 Build Your Frame**
Begin by drawing eight horizontal lines, equally spaced. You'll want them to be at least an inch or more apart to allow for details later on. Draw your character's head between lines one and two.

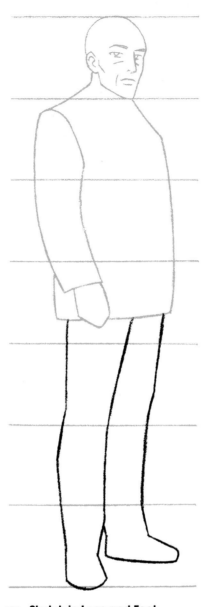

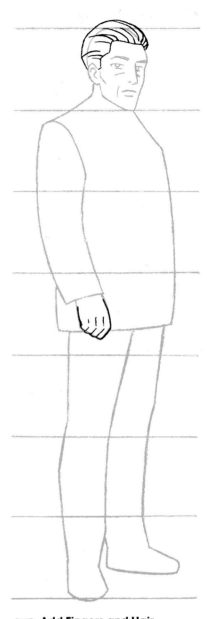

### 2 Create the Torso

Draw the neck, shoulders, torso and right arm with a rough indication of his hand. His left arm is hidden behind his body.

The bottom line of the torso is about two-thirds of the way between lines four and five. This guy's pretty big: almost three heads wide across the chest. His hand extends just a touch beyond the bottom line of his torso.

### 3 Sketch in Legs and Feet

There's no need to worry about the width of his ankles because his pants cover them.

The right foot touches line eight. The bottom line of his left foot is about one third of the way up between lines seven and eight. There is a slight diagonal lean to the legs. This will help to convey his solid, confident stance..

### 4 Add Fingers and Hair

Add a hairstyle suitable to his age and personality. You could even leave him bald.

Refine the hand, showing the curve of his fingers. The angle he's holding his hand makes the index finger look longer and hides the thumb.

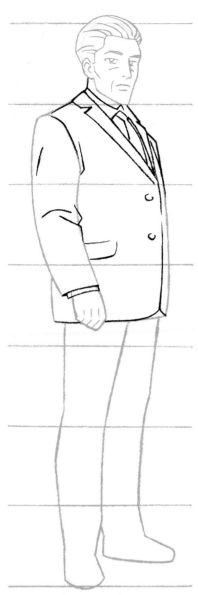

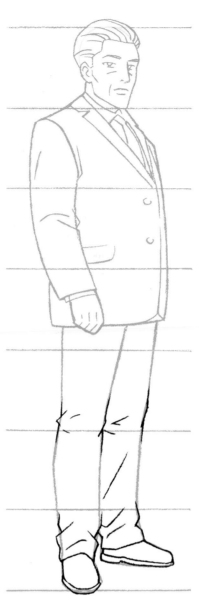

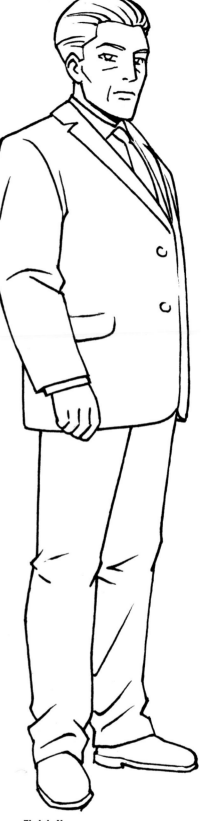

**5 Draw Clothes**
Place his tie, lapels and buttons closer to his left because he's standing at an angle. Suit coats don't wrinkle much, so draw just a few lines near the elbow and shoulder.

**6 Fine-Tune**
Add folds to his trousers and drape the cuffs following the curve of his foot.
Add soles to the bottom of his shoes.

**7 Finish It**
Add ink and, if you like, gray tones or color.
He doesn't look like a teenager, and that's exactly what we want.

**Toe the Line**

Feet are almost as hard as hands to get in proportion, and a shifting stance can make a huge difference. Check out "50 Ways to Draw Feet" to get a better look at dress shoes from the side.

# Tips on Drawing Adults

Okay, so grannies and gramps may not be your favorite characters, but you can't get by without them. Many stories hinge on an adult who provides our heroes with crucial aid and advice, or stands in their way as a formidable baddie. Here are a few tricks for making them fabulous—or fearsome!

## Middle-Aged Moms

A motherly character needs to appear observably older than her teenaged kids. Keep the lines subtle near the eyes and mouth.

## Gray Power

Draw wrinkles where they occur in real life by using a model, either in real life or from a picture.

Lines fan out from the far left and right of each eye. This creates crow's feet patterns in these areas. Lines delineating the cheekbones and small choppy lines at the lips are classic hallmarks of the elderly character. You may also add horizontal lines across the forehead and criss-crossing lines at the neck.

## Fierce Foes

Manga writers often pit youth against age, making older characters the antagonists. Give your character a prominent nose, sunken cheeks and a scowl to mark him as a worthy opponent.

Learn more about older characters at **impact-books.com/mastering-manga.**

# Fuller-Figured Girl

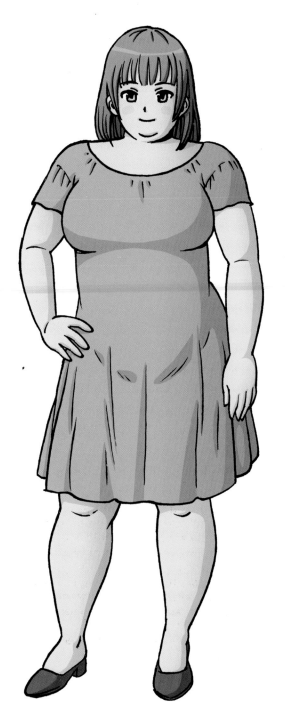

One of manga's unfortunate sides is the tendency to populate its worlds with an idealized version of humanity rather than people as they are. We all need escapism, but characters, like people, can come in all ages, shapes and sizes, right?

I've made a special effort in this book to include the fuller-figured body type, a type of character that readers come across rarely in manga. The challenge is to draw such a body as it really is, not as an object of derision. As with any artistic pursuit, once you've decided to do it, you should make sure you do it right, drawing all the lines in the places they really occur.

**1 Build Your Frame**
Begin by drawing seven horizontal lines, equally spaced. Between lines one and two, draw your character's head using what you've learned about drawing faces.

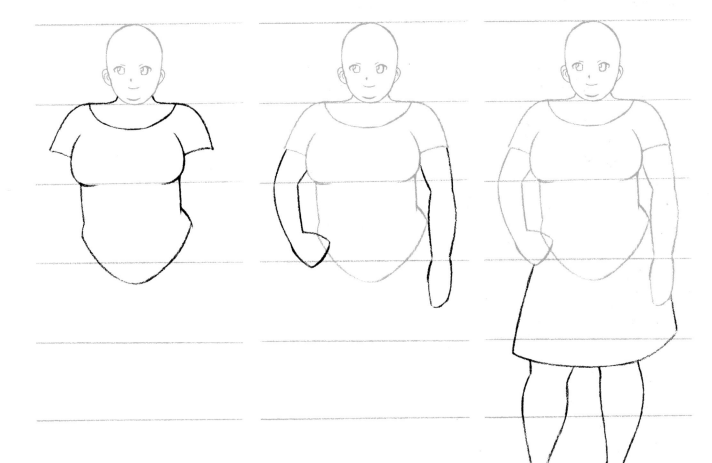

### Create the Torso

Draw the shape of the torso. The shoulders follow along line two, while the breast lines curve down to touch line three.

Her shoulders are much wider than those in our classic teen lesson, but that's because, like our adult characters, she's drawn a bit more realistically than her classic manga counterparts.

### Add the Arms and Hands

Because one hand is on her hip, only her left wrist falls directly on line four. Her right elbow is raised to land on line three.

### Add a Skirt and Legs

Her left leg is almost directly below her head because it is holding all of her weight. Her right leg is farther off to one side.

Again, the horizontal lines can serve as your guide. Place her knees just under her hemline closer to line five. Draw her ankles narrower than her knees.

Draw her toes just crossing over line seven.

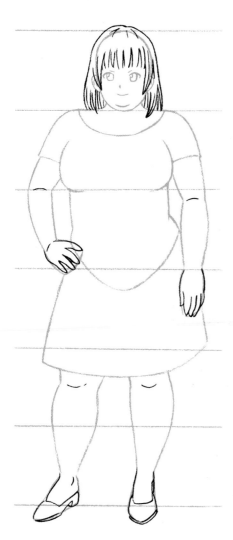

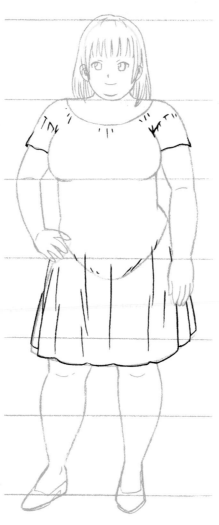

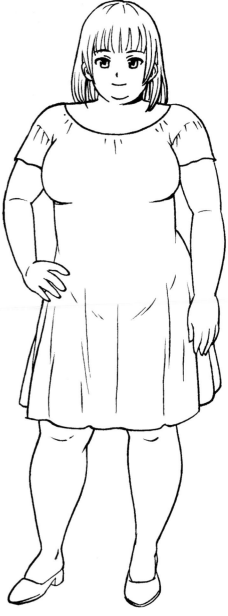

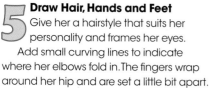

**5** **Draw Hair, Hands and Feet**
Give her a hairstyle that suits her personality and frames her eyes.

Add small curving lines to indicate where her elbows fold in. The fingers wrap around her hip and are set a little bit apart.

Draw shoes with a heel that is tall enough to be dressy, but comfortable for walking.

**6** **Fine-Tune**
Add details to the dress, including folds where the skirt drapes and small seam marks around the arms.

**7** **Finish It**
Ink it and let dry, then erase the guidelines. You can shade it, add color, or leave as is.

People come in all shapes and sizes. Why shouldn't manga characters?

# Drawing Fuller-Figured Characters

The ever-present danger when drawing fuller-figured characters is straying over the line into offensive caricature. Make sure you're not drawing them as if they're meant to be the punch line of every other joke. Studying photos of real people will help you draw these characters in a way that remains respectful.

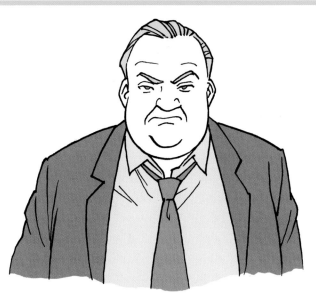

**Definite Curves**

Like all characters, a fuller-figured woman looks very different in three-quarter view.

Define the waistline with a slight indentation on her right and let it disappear behind her left arm. Her hip and the back of her upper arm line up almost vertically.

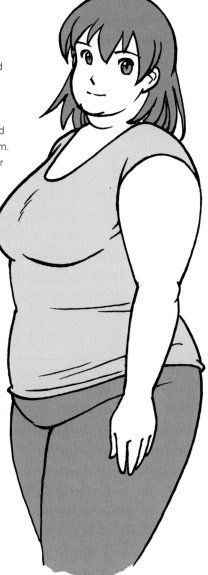

**A Powerful Figure**

Giving police chiefs and politicians a little extra size can accentuate their power by adding presence and filling the space.

This guy's head is wider at the bottom than the top, which may be a little cartoonish, but works well to establish that his word is law.

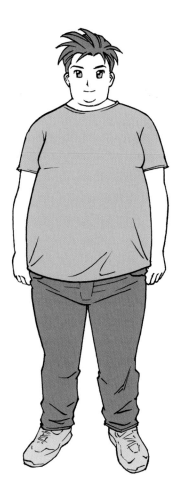

**Balanced Belly**

Make sure to balance a large belly by adding some width to the upper arms and the rest of the body.

See more characters at
impact-books.com/mastering-manga.

# The Kid Brother

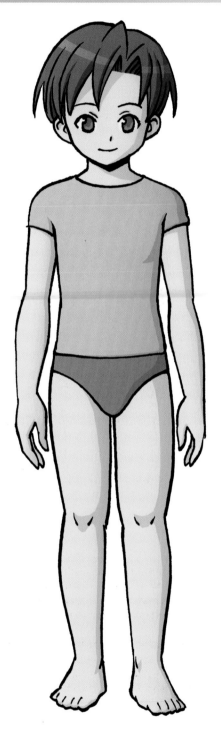

Every once in a while you come across an artist who's tried to fake his way through drawing a child by just redrawing one of his teen characters at a smaller scale. The results are laughable at best, genuinely bizarre at worst. Kids aren't just miniature teenagers! Their body proportions are entirely different from those of their older siblings.

Figuring it all out isn't that hard. It's just a matter of—you guessed it—starting with the right guidelines.

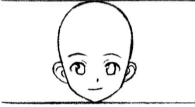

**1 Build Your Frame**
Begin by drawing six horizontal lines, equally spaced an inch or so apart.

Draw your character's head between lines one and two.

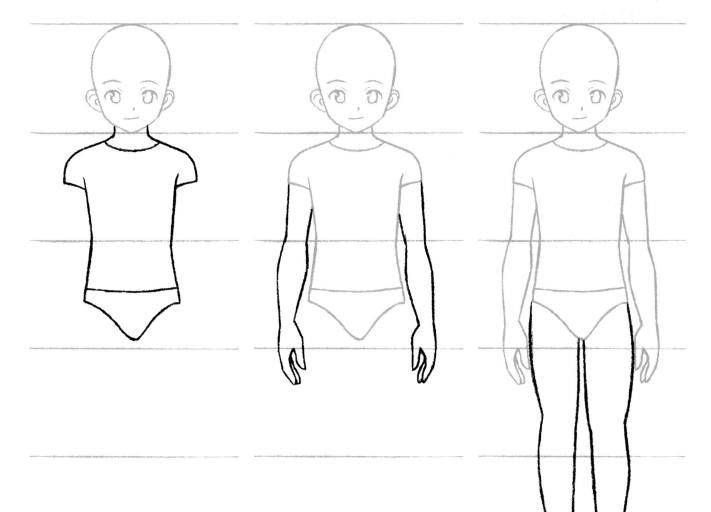

### Create the Torso

2 Draw the shape of the neck and torso. The shoulders begin just below line two, while the waistline is exactly between lines three and four. Try to get not just the lines, but the shapes. The shoulders should be a little under two heads wide, and the hips about a head and a half.

### Add Arms and Hands

3 The elbows fall exactly at line three, the wrists well above line four, while the finger tips fall below it. The wrists should be considerably narrower than the elbows.

### Sketch Legs and Feet

4 The knees sit just below midway between the fourth and fifth lines. The heels rest on line six while the toes fall below.

Make sure you capture the blank space between his legs and arms and torso. The knees are slightly wider than the ankles. His fingertips reach to about mid-thigh.

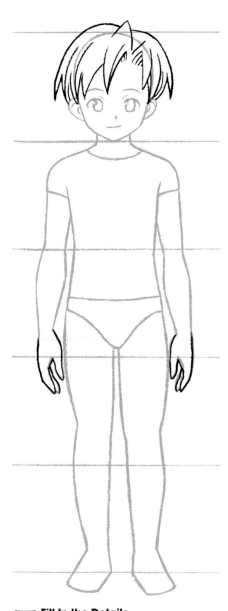

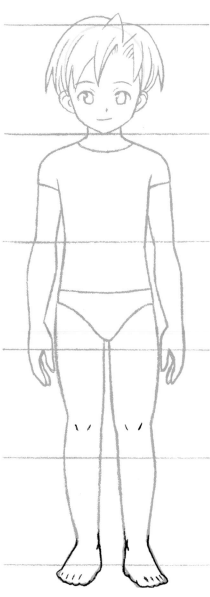

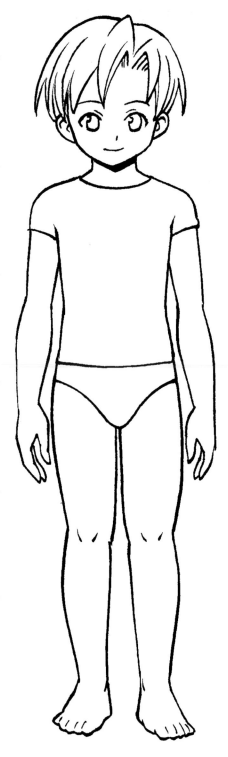

### 5 Fill In the Details

This hairstyle is less drastically kiddie than the bowl cut we saw in Heads and Faces. As a result he may appear a bit older.

Add fingers to the hands. Because of the angle, we don't see all five digits; only the index finger and thumb appear fully. The ring finger curves in toward the body.

### 6 Fine-Tune

Add toes to the feet and a couple of tiny lines to indicate the knees.

### 7 Finish It

Do the inking and let it dry, then erase the guidelines. You can add color or gray tones, or leave it as is.

# Babies and Toddlers

So now you can draw kids that don't look like miniature grown-ups. But what about babies?

It doesn't take great powers of observation to see that they're nearly as different from kids as kids are from adults. As always, it comes back to the number of heads tall. But there's more to it than that.

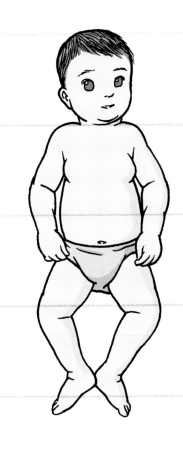

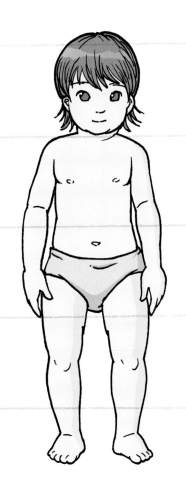

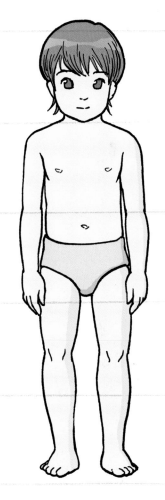

### Baby

A real baby is about four heads tall, a little more if the legs are perfectly straight. Infants are generally wider at the waist than at the chest. Throughout the early years the arms and legs are close to the same length.

### Toddler

Around the time they learn to walk, toddlers are well over four heads tall. Draw them a bit pear-shaped to account for baby fat, and yes, a bit of a double chin. Stay away from any angular lines at this age. Everything's round and curving.

### Three-Year-Old

At nearly five heads tall, our boy is beginning to leave his baby fat behind and set his sights on kindergarten. The lines are getting a little straighter. His chest is finally holding its own with his belly and his shoulders are almost two heads wide.

# Sometimes You Can't Help Being Big-Headed

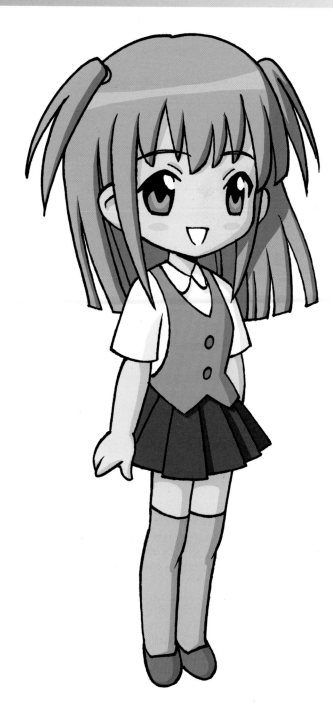

One of manga's crowning achievements is bestowing the chibi style upon the world. These ultra-cute characters have taken the world by storm, leaving smiles, hearts and oversized sweat drops in their wake.

They are by definition simpler to draw—that's the whole point! By presenting your characters in terms of their facial expressions and just enough hair and clothing to keep them recognizable, you strip them down to their very essence. But simpler to draw doesn't mean impossible to screw up. Without careful study your chibi characters will look like wannabes and not the real thing.

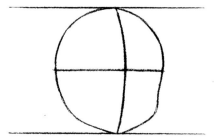

**1 Build Your Frame**
Begin by drawing four horizontal lines, equally spaced. That's right: four—this character is only three heads tall.

This character is in three-quarter view, so the head shape reveals an indication of the cheek on her left side. The curving vertical line is also off to one side about a third of the way.

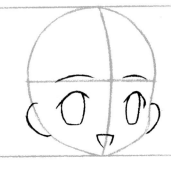

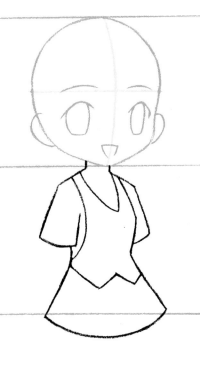

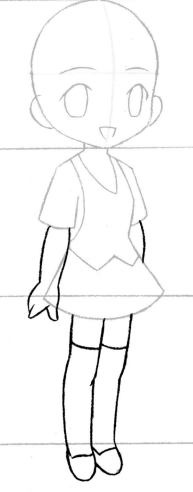

### 2 Outline the Features

Draw the eyebrows, eyes, mouth and ears. Focus on the distances between the various lines.

The eyebrows curve over the horizontal line.

The bottoms of the ears are at the same level as her jaw.

Her left eye is compressed, narrower from side to side because of the angle of her head.

### 3 Draw the Torso

Draw the neck, shoulders and clothes. The width of the shoulders is less than the head.

No need to draw the clothing exactly as I have here. Be creative and dress your chibi as you see fit.

### 4 Add Arms and Legs

Chibi feet could hardly be simpler, but pay attention to the slight forward tilt of the legs. This wave-like posture is common among standing characters, both cartoony and realistic.

Her feet cross over the bottom line while her hand extends just past line three, the same length as the dip of her skirt.

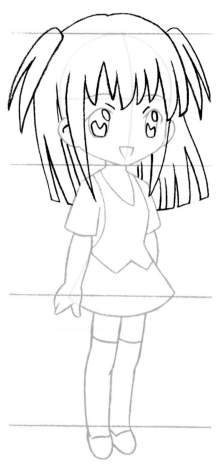

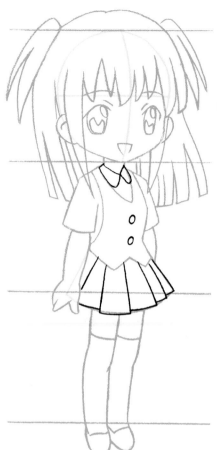

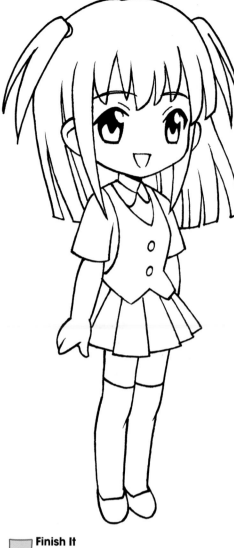

**5 Draw Hair and Eyes**

There's a considerable distance between the hairline and her actual head. If you don't draw it, your chibi's head may not look right.

**6 Fine-Tune**

Add a collar to her shirt and pleats to the skirt. You may want to go for something more casual, though.

Have fun! That's what the chibi style is all about.

**7 Finish It**

Ink it and let dry, then erase the guidelines. You can add color or leave it as is.

# Chibi Variations

Are they two heads tall? Three? Four? Hey, don't worry about it! We're drawing cartoons here, not building an interstate highway system. There is no set-in-stone number: it all depends on who's holding the pencil. Here are three of the many proportion systems out there.

### Ultra-Chibi
At a head and a half, this is pushing the chibi concept about as far as it'll go. As is often the case with chibi drawings, the feet are minimized to the point of being nearly indistinguishable from the legs.

### Moderate Chibi
This is a more common style at two and a half heads tall. The body has a bit more shape though it still doesn't approach the width of the head.

### Barely Chibi
At nearly four heads tall, probably the least common of these three approaches.

## RAGE!

If you just draw chibi characters standing there looking cute, you're missing out on the glory of the chibi style! Here's a quick lesson showing a chibi girl ticked off in a big way.

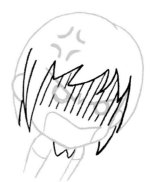

#Me all the time

### 1 Build the Frame
Draw a head with ears and a small, simple torso.

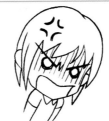

### 2 Add Features
Draw slanted eyebrows, one with a zigzagging crook at the end. The eyes are heavily outlined white circles tucked under the eyebrows. The bellowing mouth is a line that reaches all the way to the bottom of the head. Throw in a simple line for the hair and add arms and sleeves and a star-shaped vein bulging.

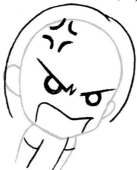

### 3 Finish It
Add jagged lines for the hair, a simple collar and a series of vertical lines across the upper half of the face. Take care not to have any of these vertical lines cross through either of the eyes. We need to leave them burning hot white.

Add Ink, erase the lines and you're done!

# 20 Chibi Emotions

Japanese manga artists have perfected techniques for conveying the breadth of human feeling in a simple cartoony shorthand. A beginning artist can master the various facial expressions in a way that is fun, not frustrating.

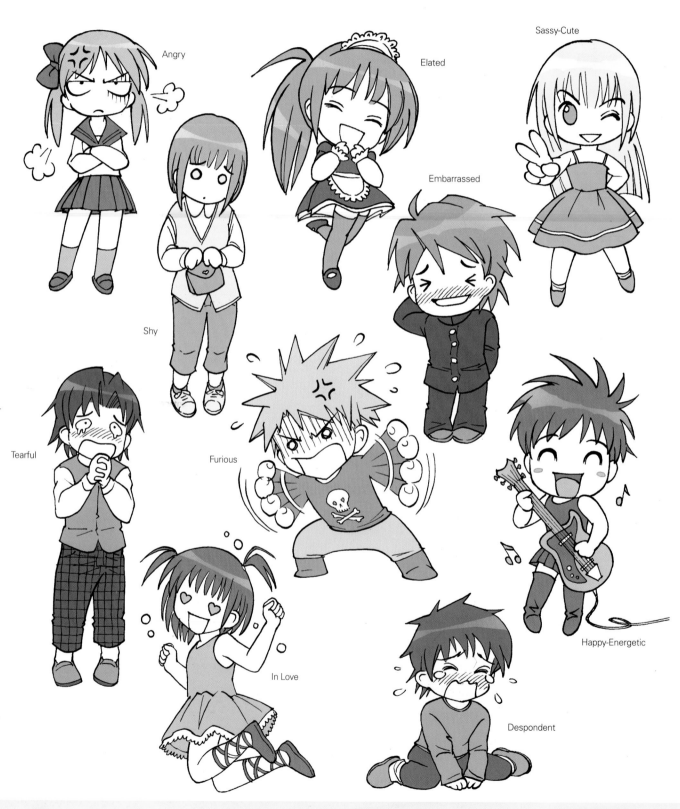

Angry

Elated

Sassy-Cute

Embarrassed

Shy

Tearful

Furious

In Love

Despondent

Happy-Energetic

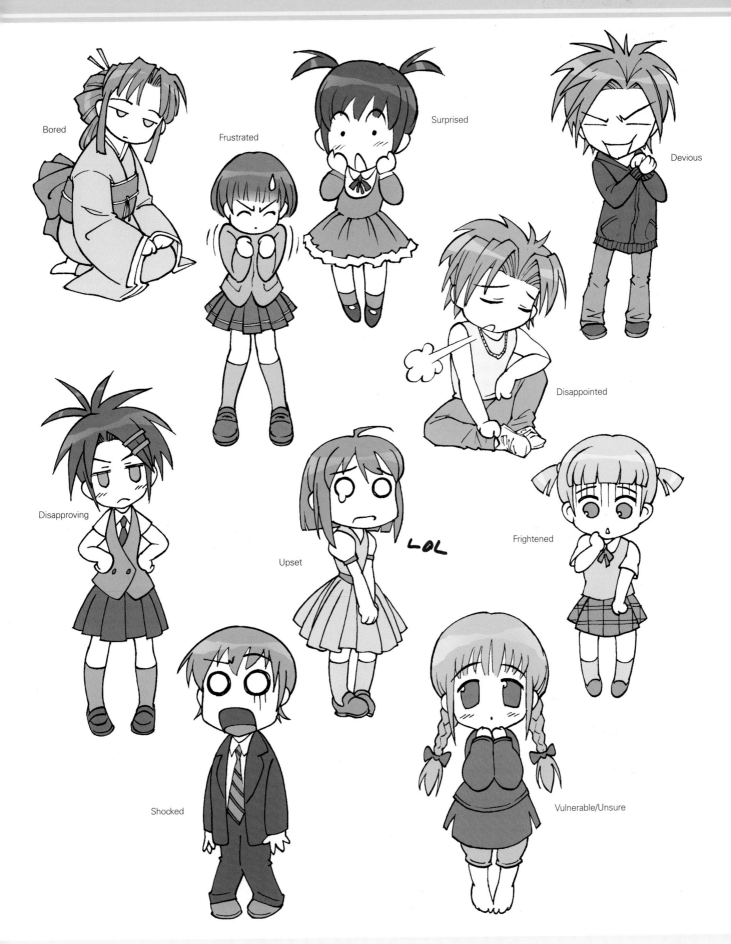

Bored

Frustrated

Surprised

Devious

Disappointed

Disapproving

Upset

LOL

Frightened

Shocked

Vulnerable/Unsure

# 50 Ways to Draw Hands

Regardless of how well you know the anatomy of the hand, it is almost impossible to accurately predict what it will look like from every angle and in every possible pose. Next time you're having trouble, use these pictures as reference.

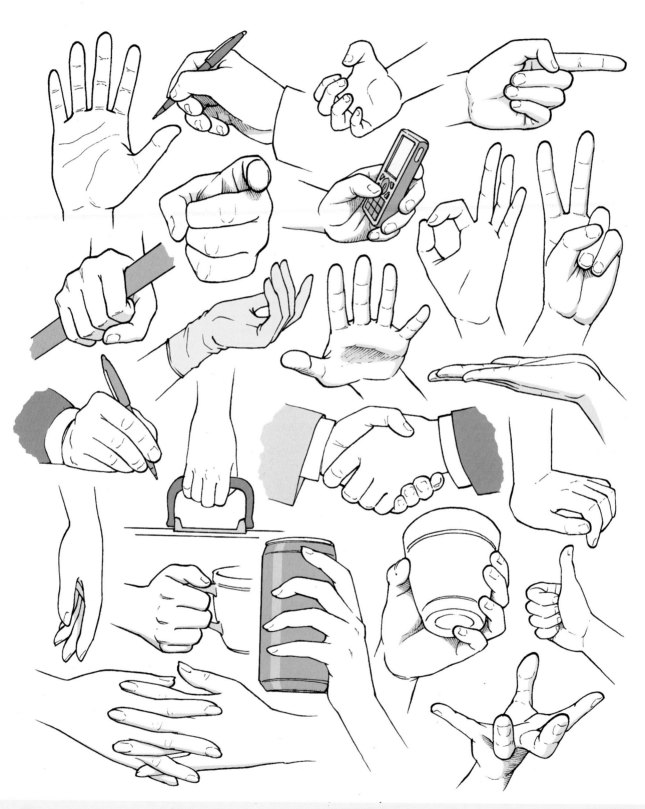

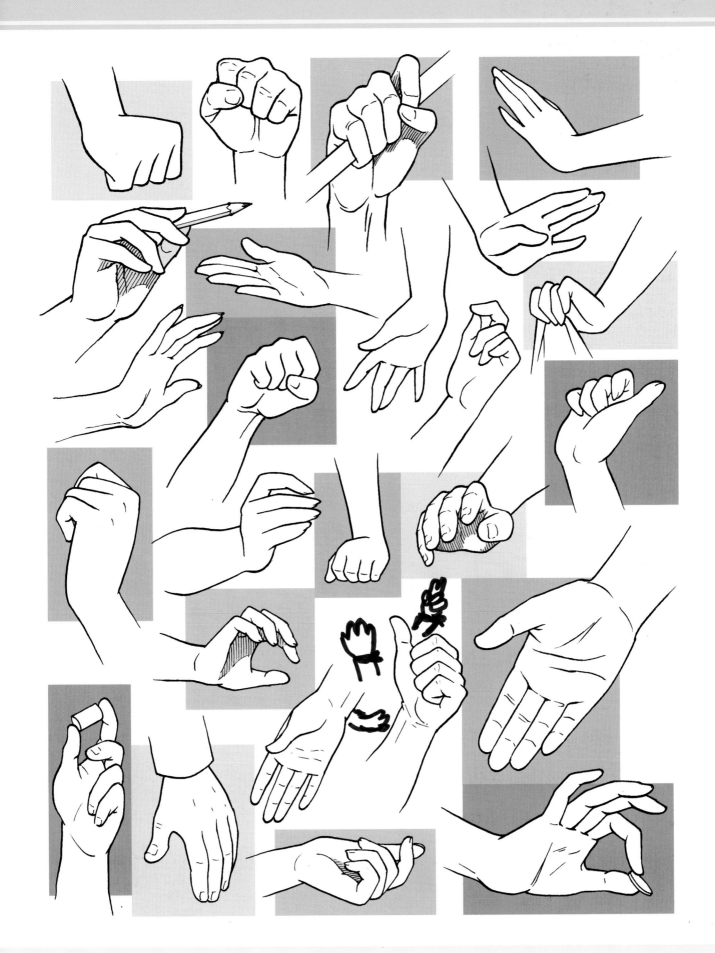

# 50 Ways to Draw Feet

Drawing feet properly can be as difficult as hands. They have a somewhat undefined shape, one that is hard to recall clearly from pretty much any angle. Rather than try to draw them from memory, use these illustrations as reference.

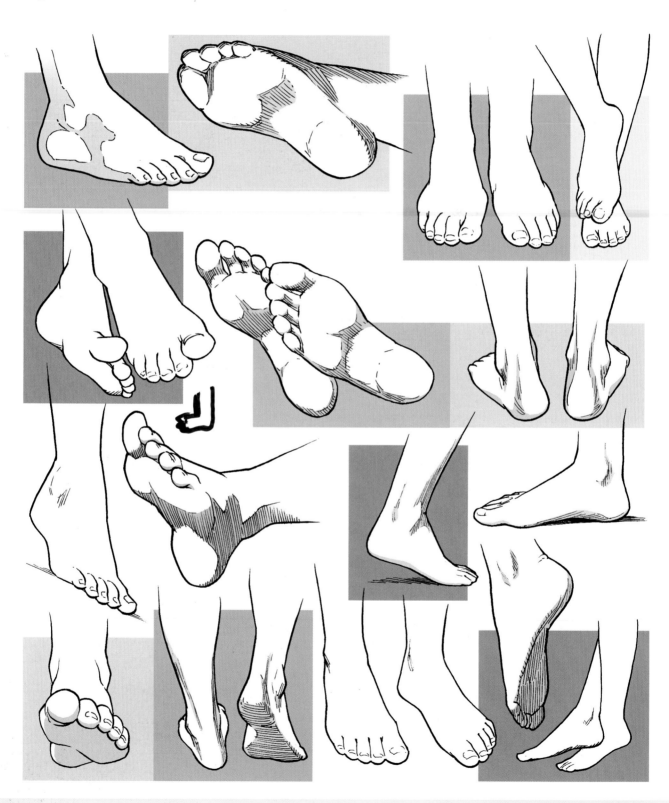

Shoes and boots present a variety of stumbling blocks. Their contours shift when seen from different angles, creating odd shapes that are hard to draw from memory. One of the trickiest challenges is when the shoes are pointing straight toward the viewer.

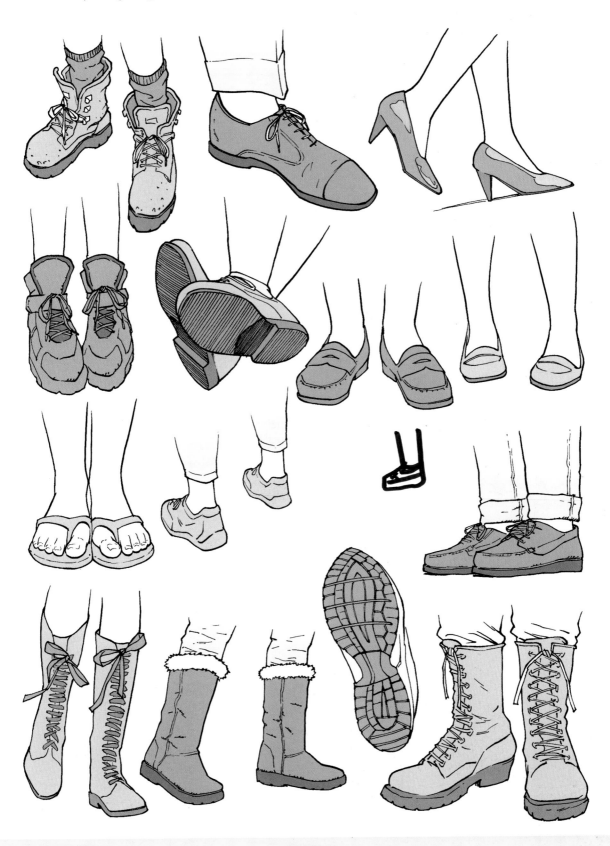

# Hitting Your Stride

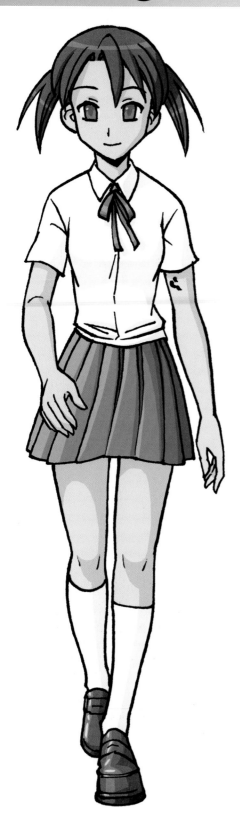

It's one thing to learn the proper body proportions of a character, but quite another to draw that character in motion. With that in mind, I decided to show you how to draw some useful manga poses.

First up is a common pose that proves difficult to draw from memory: a character walking straight toward the viewer. This pose is a staple of certain types of manga, and you may well see it multiple times over the course of a single story. Happily, it's not that hard to master.

**1 Build the Frame**
Start with seven horizontal lines, evenly spaced. Draw a female manga face using what you've already learned.

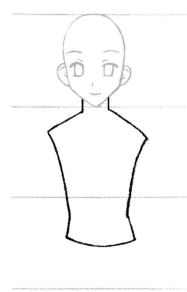

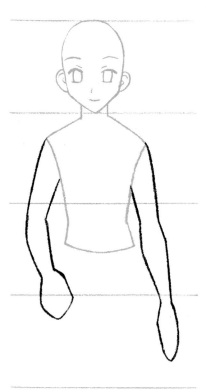

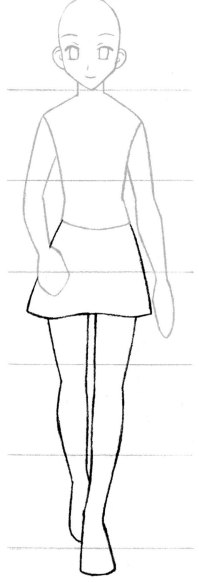

### 2 Create the Torso

In this pose the line of the waist is about halfway between lines three and four. The shoulders slope down because she's leaning slightly into her steps; they should be about a head and a half wide. The waist at its narrowest is a touch wider than her head. Use this knowledge to create the curving shape.

### 3 Add the Arms

This part is crucial to the overall walking pose. The arms move as she walks, alternating with her feet so her right arm is angling toward the viewer, bent at the elbow.

The elbows are just below line three. Her right hand is centered on line four; the other hand is well below it. Don't forget that the wrists are narrower than the elbow area.

### 4 Draw the Skirt and Legs

Start with her left leg since it over-laps her right. Her left leg tilts ever so slightly inward so that the foot is almost even with her head. Her right foot tilts inward, the foot partially concealed and the toes not quite reaching line seven.

Pay attention to the width of the thigh compared to the narrowness of the knee and even narrower ankle.

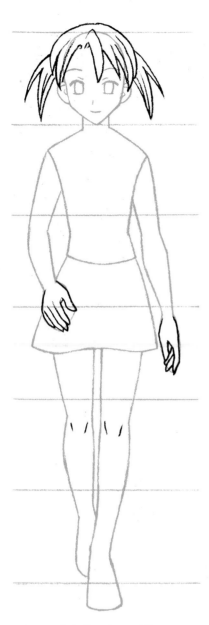

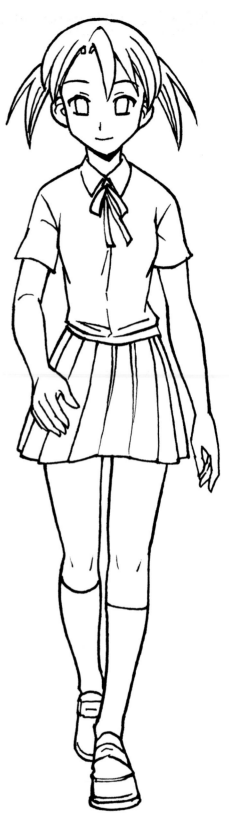

**5** **Add Hair, Hands and Knees**
A couple of tiny lines on each leg is all it takes to convey the kneecaps.
Her right hand is at a tricky angle so the little finger is barely visible.
Choose whatever hairstyle suits your character. Pigtails are always fun!

**6** **Fine-Tune**
This lesson is all about the stride and not about the clothes. What matters is that you've got the pose right: if you do she'll look great no matter what outfit you throw on her.

**7** **Finish It**
Ink it and let it dry, erase the guidelines. All done!

# Walk This Way

What could be simpler than drawing a character walking across the street? Take it from me: *loads* of things are simpler than drawing a character walking across the street! Something about the way the feet hit the ground and the legs overlap from different points of view makes walking something easier done than drawn.

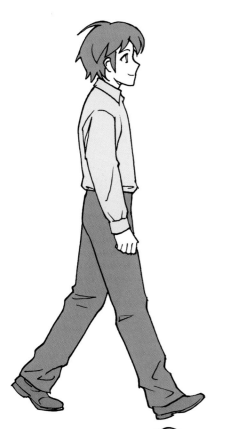

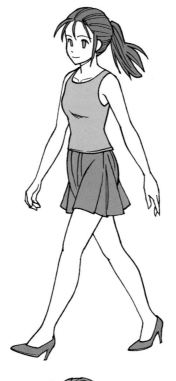

## Walking Away

When drawing a character walking away, the legs tend to point inward a bit, creating a tapering silhouette.

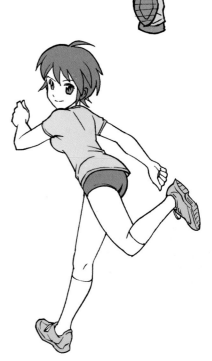

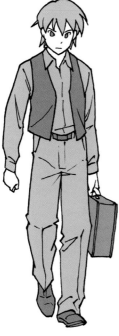

## Placing Arms and Legs

Placement of the arms and legs says a lot about the person's stride. You can tell this guy is moving slow and steady: his rear foot is only slightly off the ground and his arms are pretty much slack against his side.

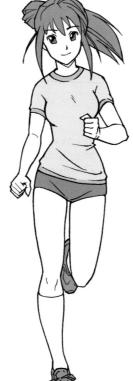

## Speed It Up

Drawing a character running is as much about the arms as the legs. The arms need to be up and in motion, one fairly straight, the other bent at the elbow.

The faster you want the run to be, the higher you place the rear foot. If her heel is nearly at the same height as her rear end, you know she's flying along at full sprint.

# Kissing

As poses go, kissing is not one you're going to draw on every page. But if you're creating a love story, you can't afford a cruddy drawing when the big moment finally arrives for your star-crossed lovers.

We're getting into advanced drawing here, and unfortunately that means pretty big leaps from one step to the other. I won't be able to walk you through each and every line. If you're a novice and easily frustrated by the tough stuff, you might want to save this one for later in your studies. For the rest of you, get ready: she's going to plant one on him, and you're going to draw it.

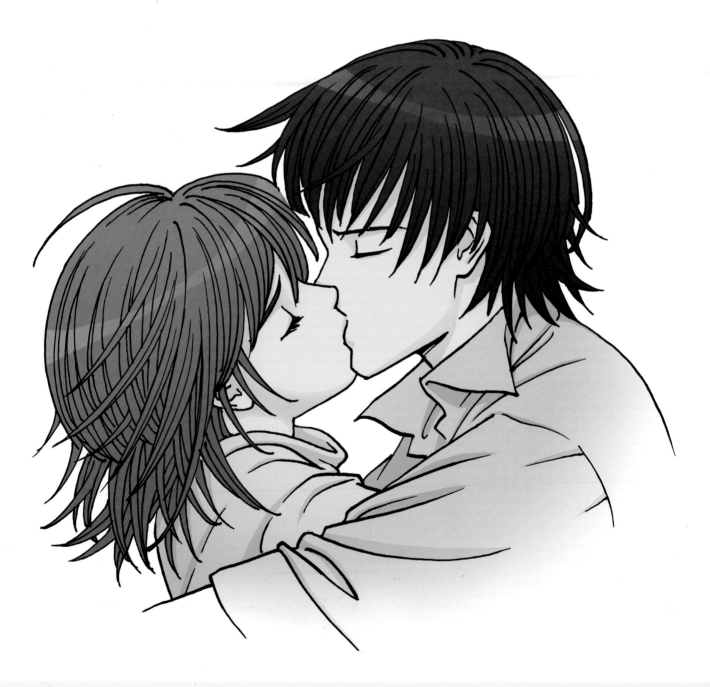

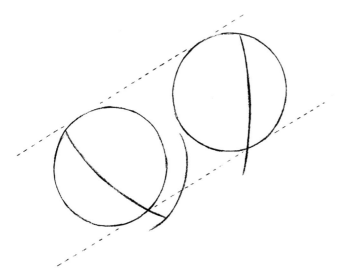

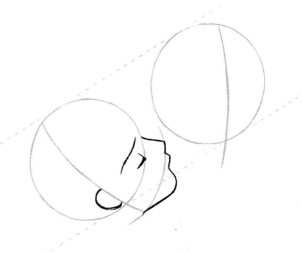

### 1 Build Your Frame

Draw two circles, one much lower on the page than the other. (I've added dotted lines to help you see the relationship between the two circles.) The circles need to be this exact distance from each other.

Add the two curving lines touching the circles, carefully replicating their angles and locations within their respective circles. Finally, add the arching line to the lower right of the circle on the left. This will help you draw the girl's face in the next step.

### 2 Outline Her Features

Take your time here, starting with very light lines. You can darken them later.

Draw the outline of her nose and jaw. This is difficult but vital to get right. It touches the circle a little less than midway between the dotted lines. The tip of the nose meets the outer arching line.

Her eye is just inside the circle, touching it, and the eyebrow sweeps back and down from near—but not touching—where her nose meets her forehead.

Draw the outline of her ear, not quite touching the circle, lining up the top with her eyebrow.

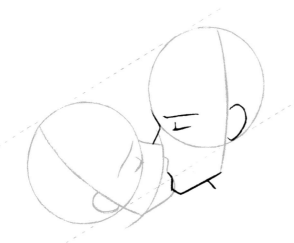

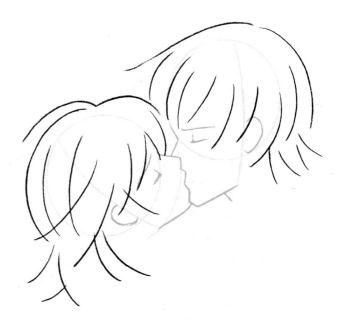

### 3 Outline His Features

She's obscuring most of his profile so you won't have to deal with that. Still, the angles of his jaw and nose lines have to be right. His jaw lines up with his ear line and meets hers. His nose line sits higher on the page, pointed down toward the girl. Use the tip of her nose like a pointer to place his eye.

### 4 Sketch In the Hair

No need to follow what I've done here. Give them both crew cuts if you like! But if you do want the classic manga look, notice how the contours of the hair are a certain distance from the circles you drew in step one. Follow too closely to those circles and your characters' heads will appear too small by manga standards.

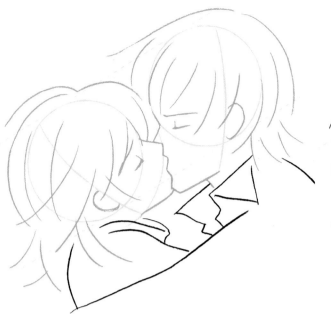

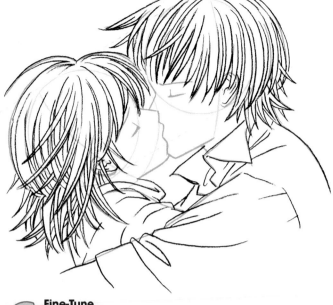

### 5 Give Them Bodies

He's leaning into her, so the line of his body should curve slightly. Her shoulder is pulled up and her face angled, which puts it much closer to her ear and she's leaning backwards.

### 6 Fine-Tune

Add folds to the clothing. Give him a shirt collar and add details to the hair.

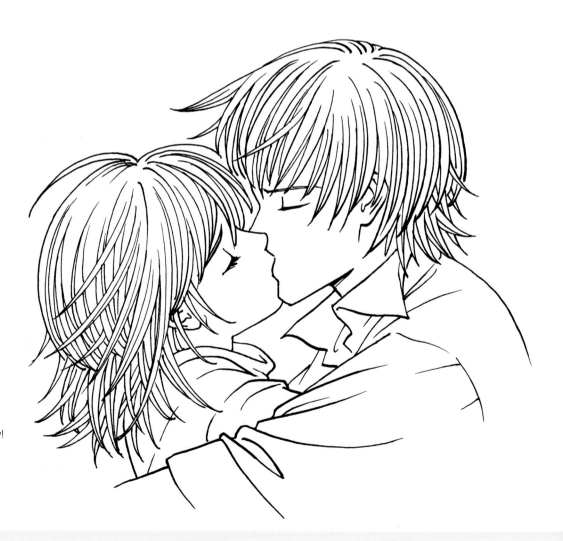

### 7 Finish It

Ink it and let it dry, then erase the guidelines.

Kissing: It's definitely easier to do than to draw!

# XOXO: Displays of Affection

Here are some reference illustrations to help you draw a variety of tender moments, not all of which involve locking lips.

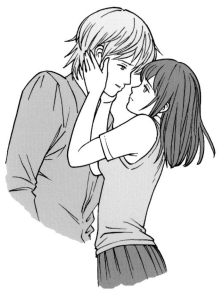

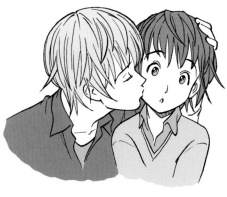

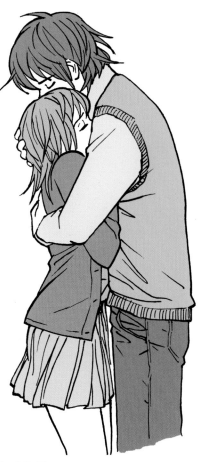

### Remember the Peck

A peck on the cheek is a cute scene to draw, and has the added bonus of allowing us a good look at the face—and inner emotional state—of the person on the receiving end of it.

### Pay Attention to the Buildup

The moment before a kiss can be just as important as the kiss itself. Her hands on his face, their noses nearly touching, this is the stuff of love stories! The angle of the eyebrows shows vulnerability that heightens the sense of intimacy.

### Cuddle Up

A warm hug can be as challenging to draw as a kiss. Characters of differing heights will each have their faces partially obscured as the embrace brings them together.

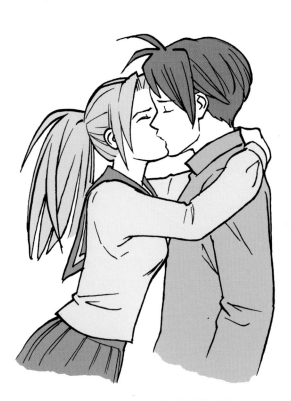

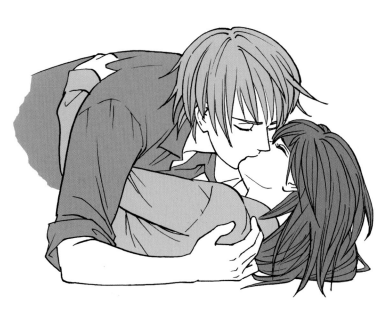

# Fighting

I'm sure a fair number of kids out there would like some big-time violence with this one—swords, blood, the works—but you've come to the wrong guy. Entrails on the floor are not my thing. I'm going to limit it to some good old-fashioned martial arts, and to me that means someone gets a foot in the face, karate-style.

Again, this is a highly advanced lesson, which means some pretty big leaps in detail from one step to the next, especially toward the end.

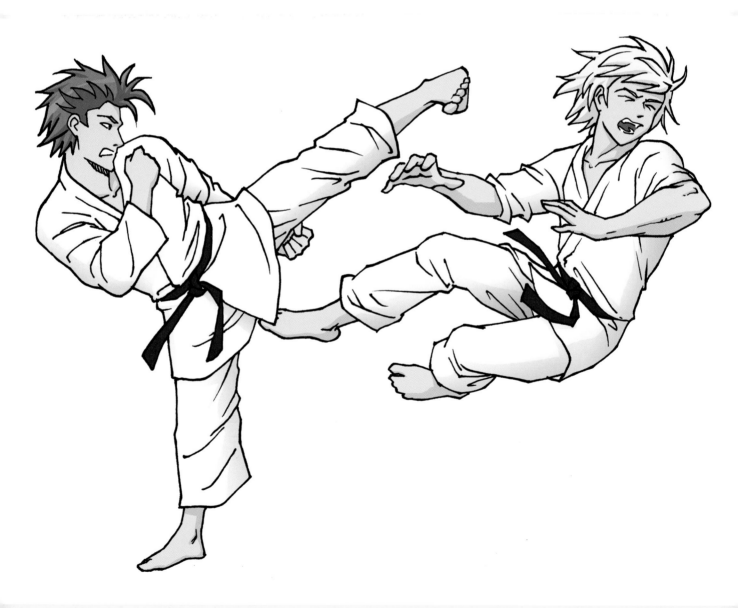

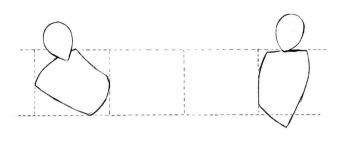

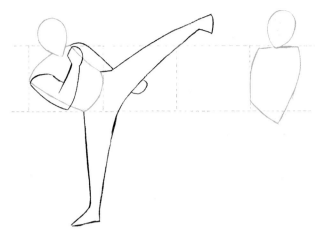

## 1 Build Your Frame

These dotted lines, divided into four equal-sized rectangles, will get us started. Draw the two torsos, fitting the one on the left into its rectangle at a diagonal. The angle of his shoulder touches the dotted line. Use the triangles formed between the torso and the dotted lines to help you get the angle right.

The one on the right is much more vertical and crosses the lower dotted line.

The first figure's head is angled up and overlaps his torso.

## 2 Outline the First Figure

Draw the kicking leg. The lower line of it intersects with the point made by your dotted lines. Make sure both legs taper properly from great width at the thighs to considerable narrowness at the ankles.

The right hand comes near to the head but doesn't quite touch it. His elbow sits almost directly in line below his chin, touching the lower dotted line. His left arm is straight behind his body.

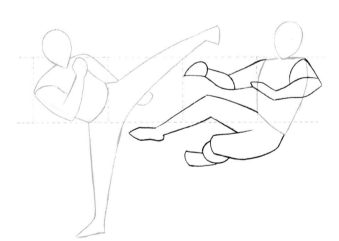

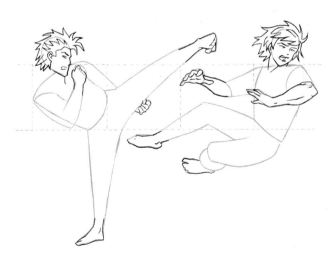

## 3 Outline Figure Two

Start with his left arm and place the forearm midway between the dotted horizontal lines. His hand angles up from the wrist. When drawing his right arm, make the tip of the hand touch the dotted vertical line.

The left leg is foreshortened from knee to ankle. To get the angle of his right leg correct, the inside of the knee should just cross above the lower dotted line and then back down. The top of the foot sits just below the line of the second box.

## 4 Add Details

Draw the heads, hands and feet. Don't sweat it if the hair is different, but you'll want the facial features to be located as accurately as possible.

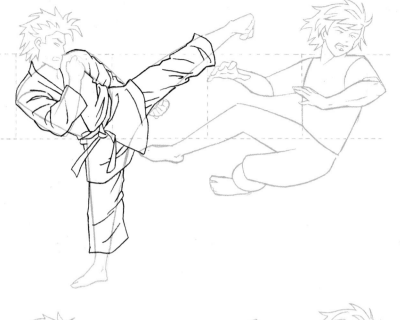

**5** **Add Clothing Lines to Figure One**
These lines don't need to be drawn with anywhere near the accuracy of those used for the face, hands or feet. No one is going to worry about the exact movement of his black belt, but do match up the movement to his action.

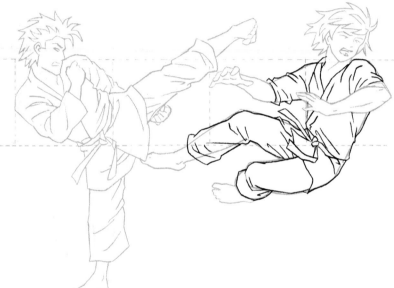

**6** **Add Clothing to Mr. Kicked-in-the-Face**
The lines don't need to be precise here either, but try to make the clothes look like they are moving with his body.

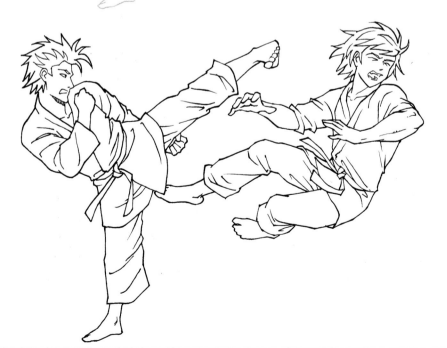

**7** **Finish It**
Ink and let dry, then erase the guidelines. No doubt about it, one of these guys is having a better day than the other.

# The Fight Club

No shonen manga would be complete without adversaries clashing in battle. When it comes to blows—or even just a menacing stare down—you need poses at your disposal that deliver the goods to your action-hungry readers. Next time you need to spruce up a fight scene, come to this page and borrow an idea or two.

### Blast Off

Many manga stories involve battles between adversaries with supernatural abilities. In these scenes the only weapons may be the characters' hands and their ability to conjure blasts of energy out of the air.

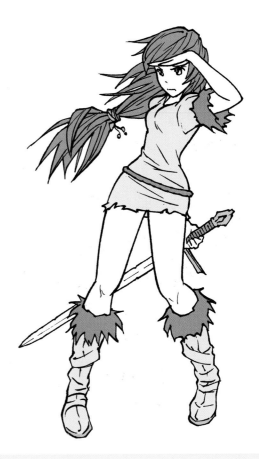

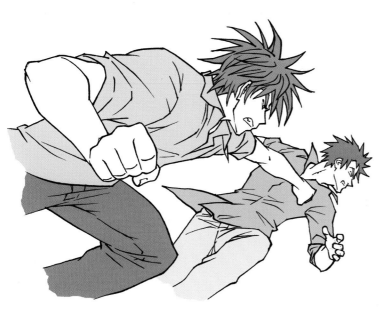

### KO!

Showing one character punching another is going to be one of the most intense moments of your story, so present it as dramatically as possible. By bringing the boy's free arm closer to the viewer, you accentuate the depth of the scene and make readers feel how far back the other guy has been knocked.

# 30 Classic Poses

Here are thirty classic manga poses that you can adapt to fit your own characters. By doing careful studies of these illustrations you can also improve your sense of manga body proportions. Try changing an arm or leg position to create poses all your own.

**Don't Just Stand There**
Part of the challenge to drawing a proper standing pose is keeping the character relaxed. The solution is to create the sense of a gentle wave in the body. It starts in the shoulders (back), flows to the hips (forward), and continues down to the feet (back again).

**Sitting Around**
One of my favorite female poses is this simple but charming "sitting on the floor" pose. It has the advantage of creating an interesting contour, virtually guaranteeing a nice page composition.

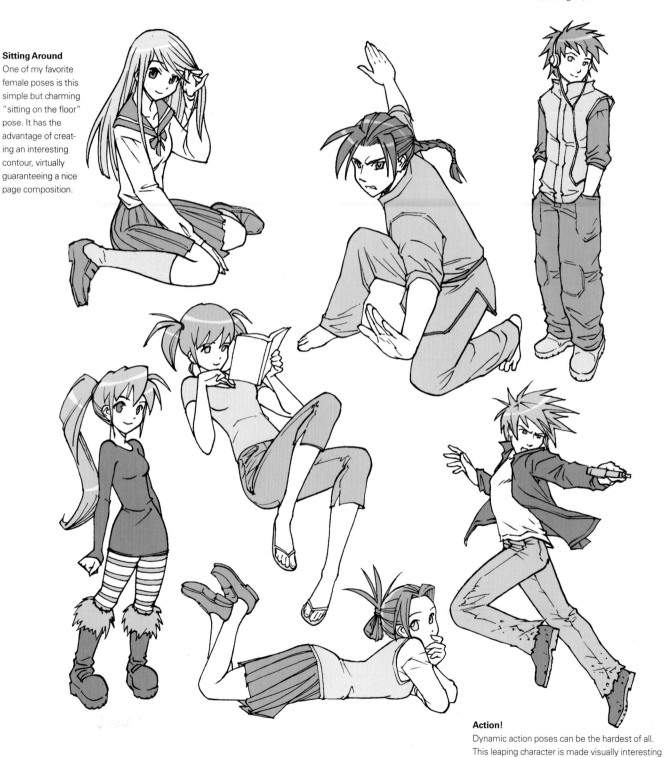

**Action!**
Dynamic action poses can be the hardest of all. This leaping character is made visually interesting by his body's heading in one direction while his head and arm are twisting back in another.

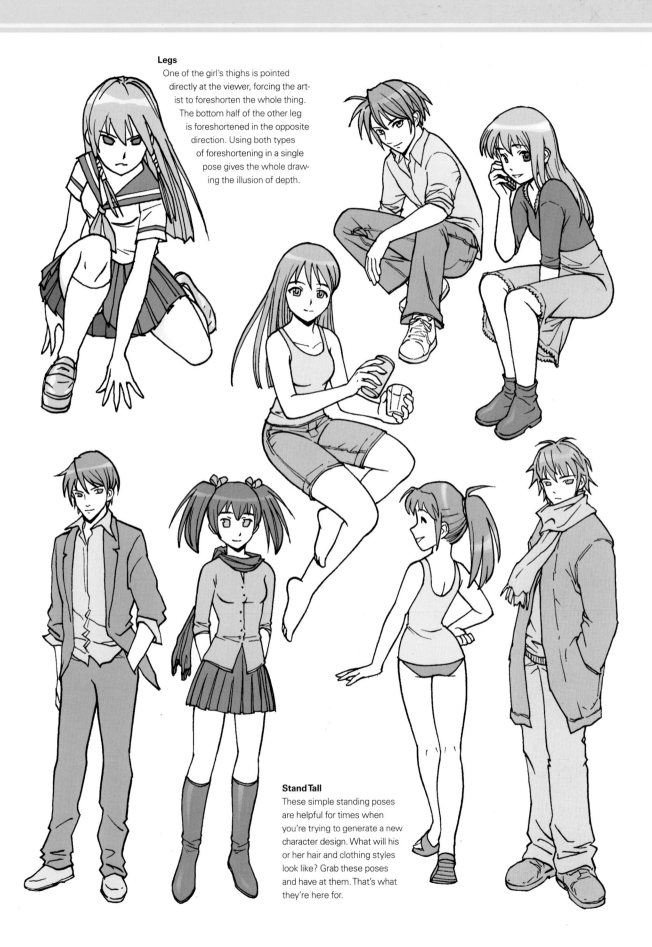

**Legs**
One of the girl's thighs is pointed directly at the viewer, forcing the artist to foreshorten the whole thing. The bottom half of the other leg is foreshortened in the opposite direction. Using both types of foreshortening in a single pose gives the whole drawing the illusion of depth.

**Stand Tall**
These simple standing poses are helpful for times when you're trying to generate a new character design. What will his or her hair and clothing styles look like? Grab these poses and have at them. That's what they're here for.

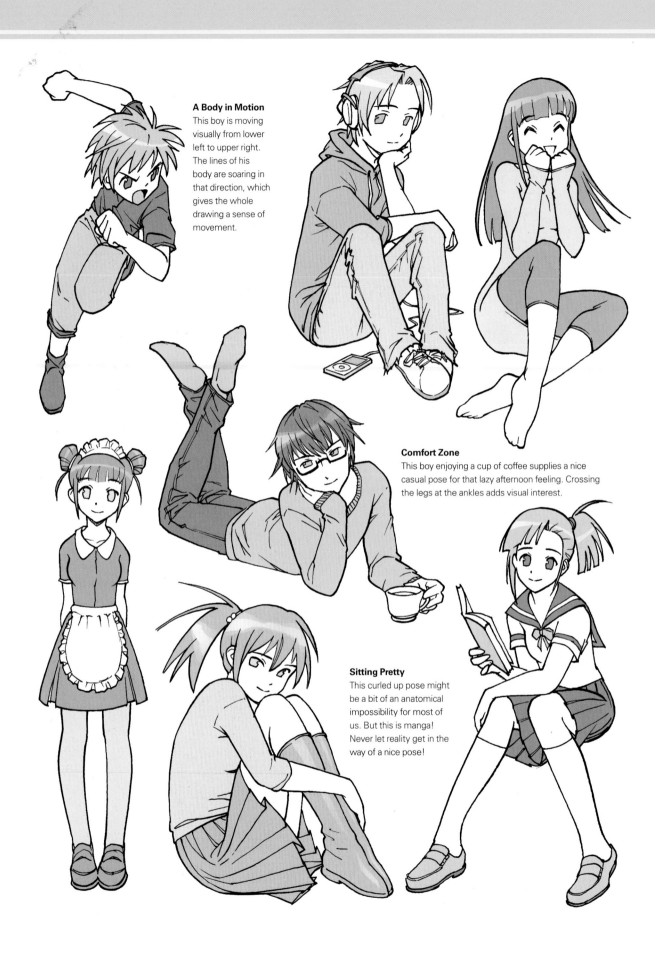

**A Body in Motion**
This boy is moving visually from lower left to upper right. The lines of his body are soaring in that direction, which gives the whole drawing a sense of movement.

**Comfort Zone**
This boy enjoying a cup of coffee supplies a nice casual pose for that lazy afternoon feeling. Crossing the legs at the ankles adds visual interest.

**Sitting Pretty**
This curled up pose might be a bit of an anatomical impossibility for most of us. But this is manga! Never let reality get in the way of a nice pose!

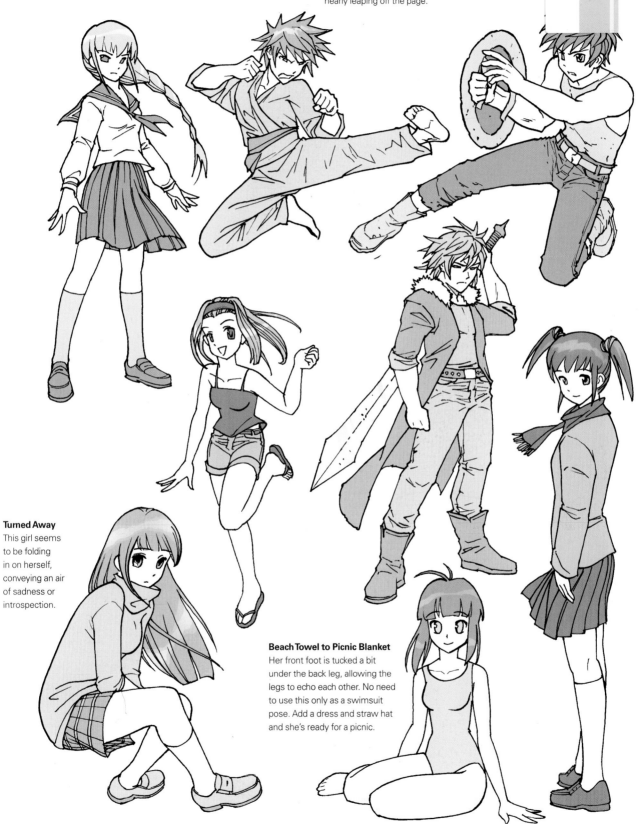

**For Kicks**
The legs in such poses go off in incredibly dramatic angles, creating visually dynamic contours and very nearly leaping off the page.

**Turned Away**
This girl seems to be folding in on herself, conveying an air of sadness or introspection.

**Beach Towel to Picnic Blanket**
Her front foot is tucked a bit under the back leg, allowing the legs to echo each other. No need to use this only as a swimsuit pose. Add a dress and straw hat and she's ready for a picnic.

# thing Folds and Wrinkles

It's no wonder beginning artists of all kinds struggle with drawing folds in clothing. The sheer number of lines involved is daunting!

Let's look at various types of clothing and focus on where the folds tend to occur, starting with a shirt sleeve.

### Armrest

An arm at rest tends to produce folds in three different places: the shoulder, the inner elbow and above the cuff.

### Elbows Out

When the arm bends, the shoulder lines change direction while the number of elbow lines increases and a third set of lines emerge across the forearm.

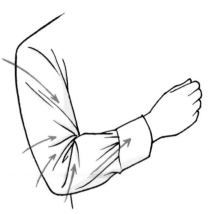

### Around the Bend

When the arm bends tight, lines emerge across the upper arm. Lines at the inner elbow fan out and lines emerge near the cuff showing greater tension on the sleeve.

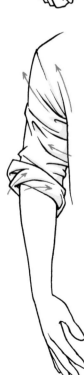

### Rolling Along

A rolled-up sleeve presents a challenge when rendering the folded cloth properly at the elbow. There tend to be extra folds across the upper arm as the sleeve folds in on itself.

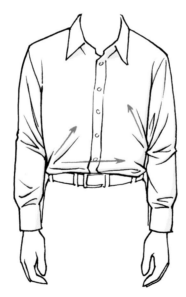

### Tucked In

The folds of a dress shirt emerge near the waist diagonally from the bottom corners and horizontally from side to side where the shirt is tucked into pants.

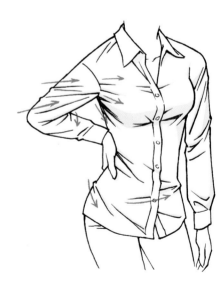

### Figure Drawing

A woman's body produces folds a man's won't. Note the small, short lines that fan out from the shoulder area across the bust. A shirt that is untucked will produce horizontal folds near the waist and diagonal ones elsewhere.

# Dress Pants and Jeans

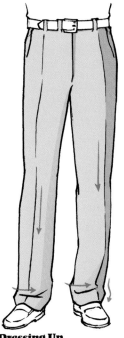
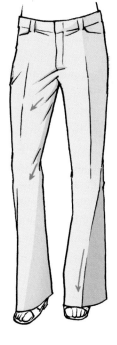

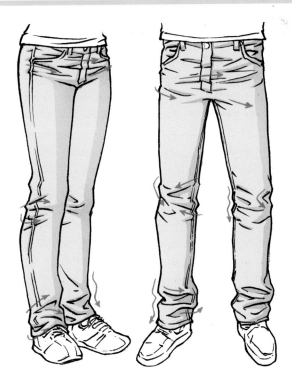

## Dressing Up

Dress pants are designed to create as few wrinkles as possible, resulting in long vertical lines and smooth, uninterrupted contours.

## Denim Danger

Wrinkles erupt all over the place with denim, but particularly in the areas of the waist, knees and ankles. The silhouette lines of a pair of blue jeans get a bit zigzaggy near the knees and even more so at the ankles.

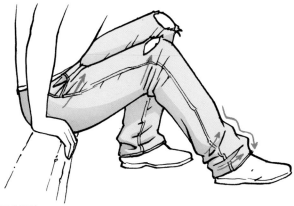

## Fold Lines

When a person crouches down or sits on a curb, wrinkles pull across the legs with much greater tension than usual. Even so, it's still the waist, knees and ankles that get the most folds.

Find more about clothing folds at impact-books.com/mastering-manga.

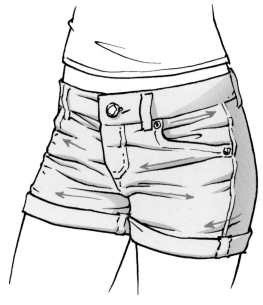

## Short and Sweet

A pair of shorts is no different from a pair of jeans in terms of the wrinkles that emerge near the waist. The dominant direction is horizontal as the cloth is pulled from side to side.

# Skirts

Wrinkles on skirts are considerably less complicated than those on shirts and blue jeans. They seem to fall into one of two types in terms of folds: pleated skirts, in which the folds are largely vertical, and straight skirts, in which the few wrinkles tend to go horizontal.

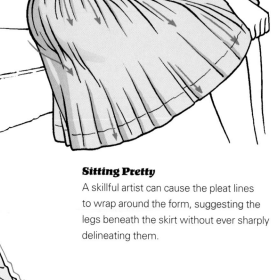

### Sitting Pretty

A skillful artist can cause the pleat lines to wrap around the form, suggesting the legs beneath the skirt without ever sharply delineating them.

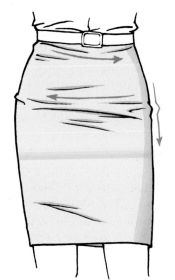

### Thigh Lines

A seam along the thigh may produce a great number of mini-folds.

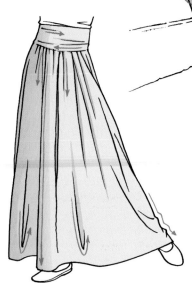

### Hook, Line and Sinker

Long skirts create vertical lines that extend from the waist to the floor. A few of the lines may have small hooks at the end.

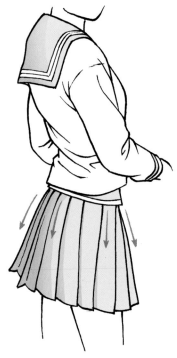

### Lineup

This classic sailor suit skirt produces a regular array of near-vertical lines that fan out from the waist.

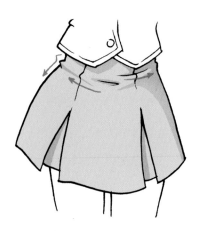

### Pleating our Case

Pleated skirts divide into a few large, flat areas of cloth. In these skirts you may see a few horizontal wrinkles near the waist.

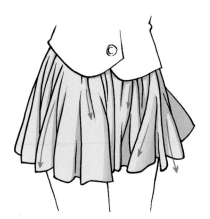

### Skirting the Issue

A floppy skirt produces unpredictable wrinkles. The cloth folds in on itself at irregular intervals, creating a mass of vertical and diagonal lines.

# T-Shirts, Sweaters and Coats

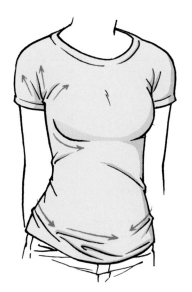

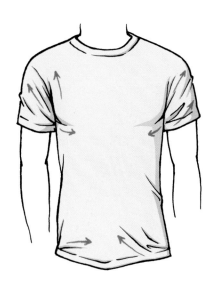

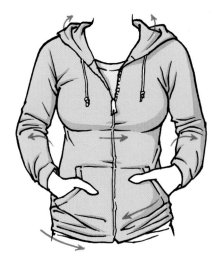

### Tricky Tees

You'd think a T-shirt would be easy enough to draw, but its wrinkles can trip you up. The lines tend to fan out from the underarm area, then gather more prominently around the waist.

### Hooded Figure

A hoodie can give your character a nice casual feel, but prepare yourself for a challenge if you're going to have her wear it all the time. It's wrinkles galore in all the usual places, plus new folds around the pockets and along the edges of the hood.

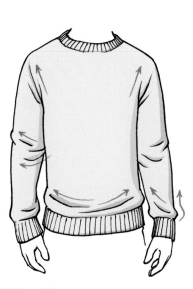

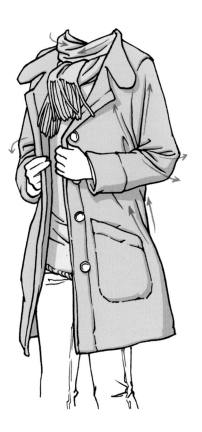

### Weighted Down

A thick sweater will produce noticeably fewer lines than a dress shirt, owing to its thick material.

### Outer Layers

The wrinkles of winter coats will differ greatly depending on what material they're made of. A dress coat will reveal a minimum of folds, but an outdoorsy coat will be among the biggest wrinkle-fests you'll ever encounter.

# Setting the Scene

When we think of manga, the faces and poses are the first things that come to mind. But all those cool characters can't just float around in the ether all day. Your drawings won't be complete without settings for the characters to inhabit, and you won't be able to render those settings convincingly without a basic understanding of perspective. Complicated? A little, but nothing that can't be acquired with a little practice. Learn the ropes of layouts, word balloons and sound effects, and you'll have everything you'll need to make your first manga story.

# Fundamentals of Perspective

There's no reason you shouldn't be able to draw anything you want in perfect perspective, provided you're serious about learning the basic laws of vanishing points and the lines that lead toward them. Let's start with the simplest and possibly the most useful of the three forms of perspective.

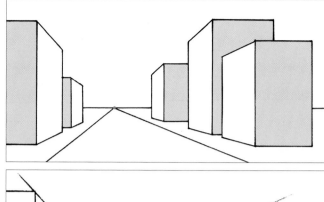

### One-Point Perspective

If you've ever stood on a straight stretch of railroad track and looked way down to where rails almost seem to touch, you've seen this style of perspective in action. Though in a real street these lines would be parallel, in a one-point perspective, they merge together as they reach the horizon. This is the vanishing point.

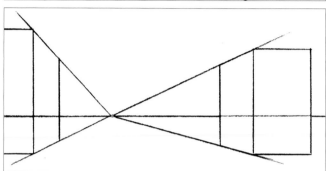

## WARM-UP

Follow this brief step-by-step lesson to draw an open cardboard box in perspective. It may not look like a masterpiece, but it'll help you understand the basic concept of how it all works. Since all the other perspectives build on the same concept, once you've mastered this, you can conquer those tricky backgrounds.

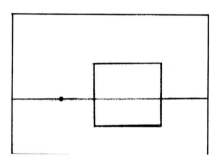

**1** Draw a horizon line, place a dot on it, and then draw a box alongside it. Try to put your box in the exact same location I did for the best results.

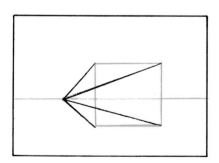

**2** Now use your ruler to draw four light lines, one from each of the four corners of the box, all the way to the vanishing point.

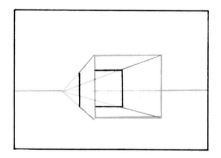

**3** Draw a second, smaller square inside the first box, taking care to make the corners of the square rest upon the perspective lines. Leave part of the square incomplete. That area will become the opaque side of the box.

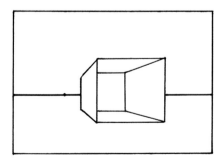

**4** Ink the lines of the box and visible horizon line. Erase your pencil lines once the ink is dry.
You have an open cardboard box drawn in absolutely perfect one-point perspective.

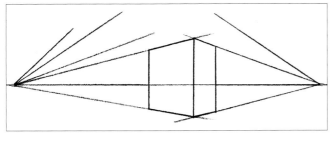

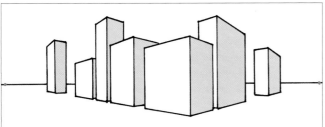

### Two-Point Perspective

Unlike one-point perspective, which merges into a single vanishing point, two-point perspective has two vanishing points set far apart from each other along the horizon line. You've seen this when you've stood on a street corner. The tops and bottoms of each building point toward their respective vanishing points.

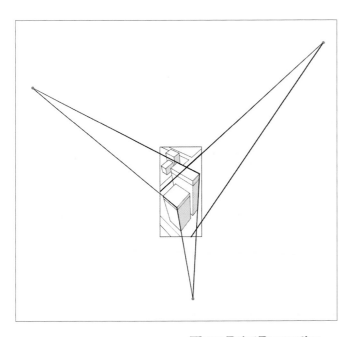

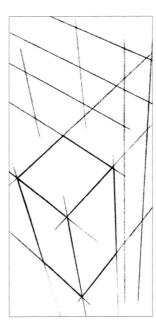

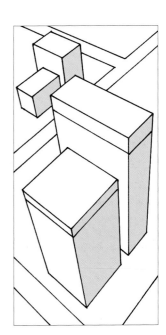

### Three-Point Perspective

Three-point perspective is what you'd see from above (bird's-eye view). The three points need to be very widely spaced for the perspective to look natural and convincing. There is no horizon line.

There is logic to this. Let's say all the "north-south" streets are heading off toward the upper right-hand point. The "east-west" streets will all point toward the upper left-hand point. And the sides of the buildings will all point down toward the bottom point.

It's a lot of work, no getting around it. But if you master the three-point perspective, you'll be rewarded with a bird's-eye view that's as good as anything you'd get from a helicopter.

# Street Scene Using One-Point Perspective

If you stand on a city sidewalk and see how it recedes into the distance, getting smaller and smaller, you have very nearly entered a living example of a one-point perspective drawing.

There will be many more lines than in our warm-up lesson on this subject, but there's never going to be anything other than one horizon line and one vanishing point.

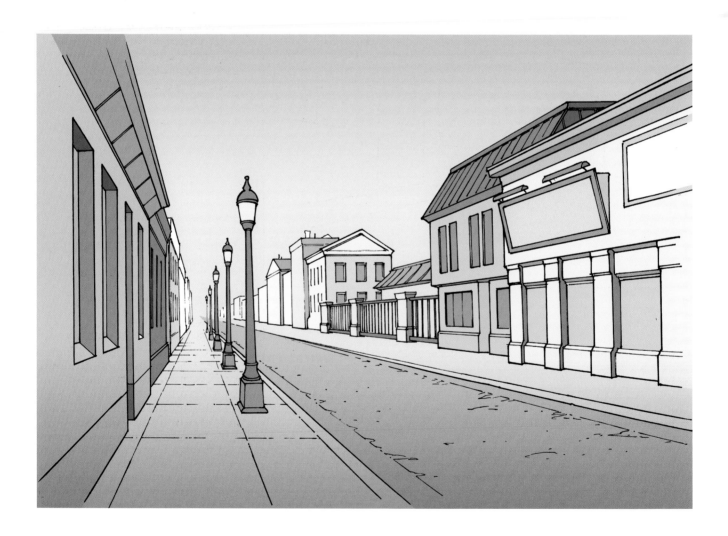

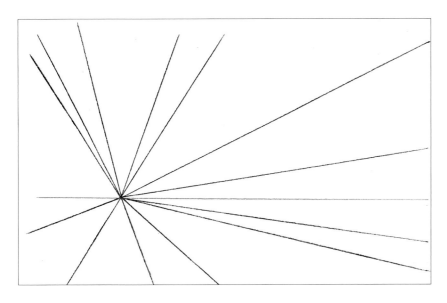

### 1 Build Your Frame

Begin by drawing a wide horizon line, indicated here in red, then place your vanishing point about one-fifth of the way from the left. With your ruler, make lines emanating from the vanishing point. Think about how many lines you'll need for the street, the sidewalk, the bottoms and tops of buildings, etc.

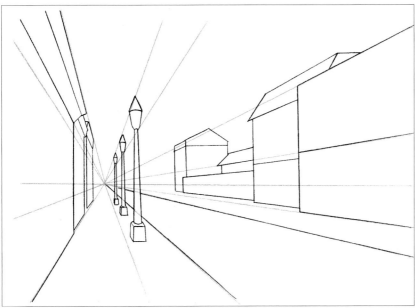

### 2 Draw the Sidewalk and Buildings

Use the lines as your guide to determine heights and widths. With the buildings on the right it will be easiest to start with the closest building since it overlaps the next building down.

Add lampposts if you like.

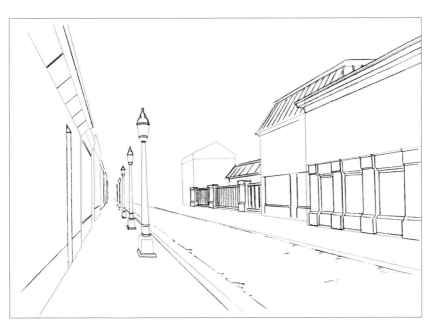

### 3 Add Details

Extra details like the columns on the closest building on the right will give your scene variety and make it more convincing. If you opted for lampposts, now's the time to add more detail to them. As you add all of these extra lines, you will be struck by how many of them lead right back to that one crucial vanishing point.

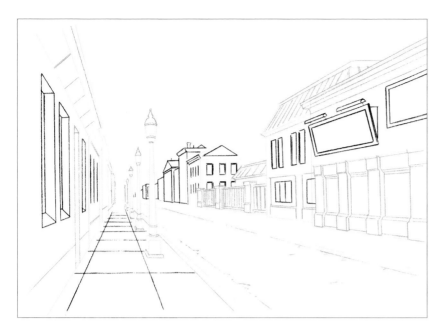

### 4 Fine-Tune

Fill in windows and other details to the buildings. The sidewalk lines shouldn't give you too much trouble.

The area of buildings in the distance on the right-hand side is a good place to experiment. Make your buildings taller or give them different style rooftops.

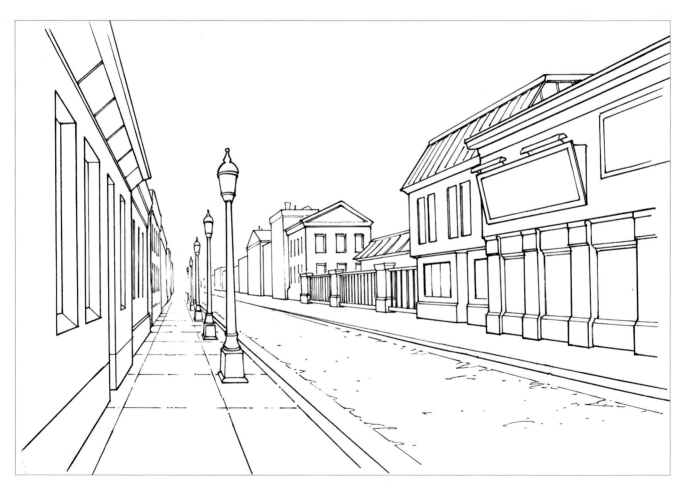

### 5 Finish It

Ink all the lines. Inking with a ruler can be challenging, so try different rulers to find one that doesn't smear the ink. Let it dry, then erase the guidelines, and you have a city scene that obeys the laws of perspective every bit as much as one does in real life.

# Objects Big and Small

Just because it's the simplest doesn't mean a one-point perspective can't result in highly sophisticated drawings. It's all down to you, your creativity and the amount of structural detail you're willing to add. Here are a few more ideas for putting one-point perspective to work.

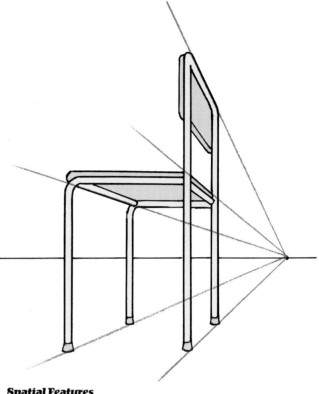

### Picture Perfect

This picture frame, presented as it might be seen by a child looking up at it on the wall, is a legitimate one-point perspective drawing. If you followed those red lines on the left and right as far as they go, they would eventually intersect at a vanishing point.

### Spatial Features

Take a good look at this chair because you're going to see it again. See how even the bottoms of the chair legs are touching the perspective lines? If they didn't, the chair wouldn't look like it was firmly on the ground.

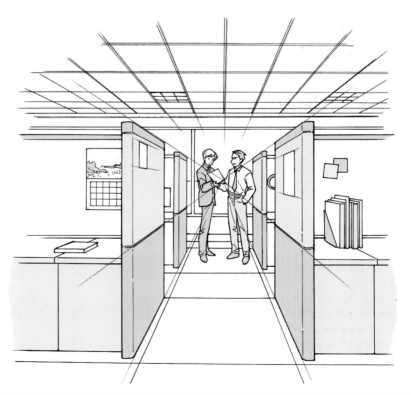

### Office Space

Not all one-point perspective environments are of the city sidewalk-type outdoor scenes. This office interior is ideal for the one-point approach. If I had tried to wing it without establishing a real vanishing point, the sense of space would be nowhere near as convincing.

# House Interior Using Two-Point Perspective

We tend to think of exterior scenes as the best examples of perspective drawings, but as a manga creator you'll be using these skills at least as often for drawing rooms and other interior spaces.

One thing that complicates matters is that the heart of your drawing is often a considerable distance from at least one of the vanishing points. It's worth temporarily taping on a separate sheet of paper to provide yourself with the second vanishing point you need.

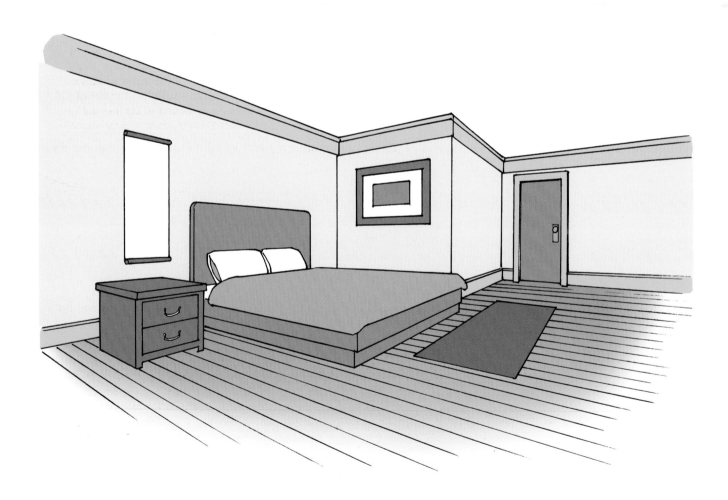

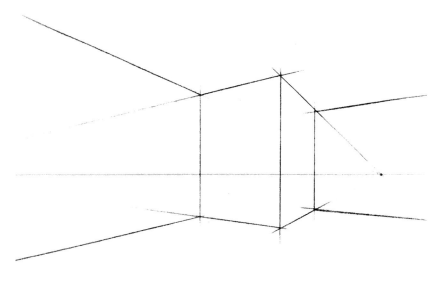

### Build Your Frame

Begin with a horizon line and two vanishing points a good distance from each other. Now use those two vanishing points to create these intersecting walls. The right-hand surfaces all recede toward the left vanishing point. The left-hand surfaces all recede toward the right vanishing point.

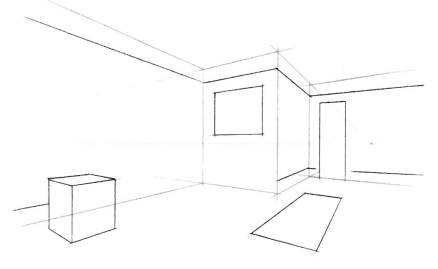

### Outline the Features

Add a few details like borders near the ceiling and floor, a picture frame and door, a table (essentially a simple box at this stage) and a small rectangular carpet. All the lines but the verticals will be pointing toward one of the two vanishing points.

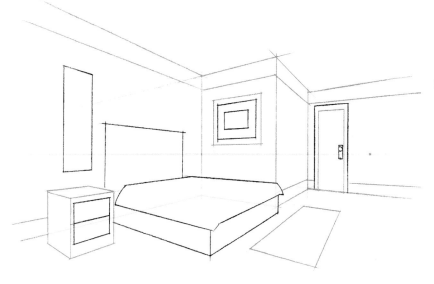

### Add Details

Draw a bed and more details on the door, picture frame and table. Most of the lines of the bed are following along with the perspective lines. Only the corners of the comforter are tapering off and doing their own thing, which keeps the comforter soft; otherwise it'll look like it's made of stainless steel!

You can add a hanging scroll on the left wall—it was looking a little empty.

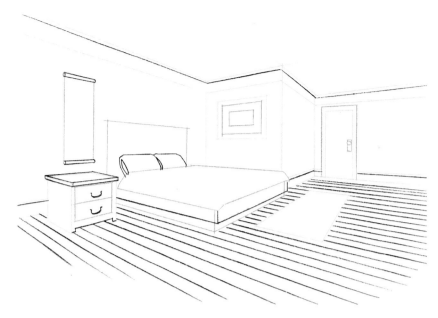

### 4 Fine-Tune

Add another line or two on the borders, further structural detail on the table, and pillows on the bed. If you have the patience for a hardwood floor, then drop it in. Every one of its lines will point toward the left vanishing point.

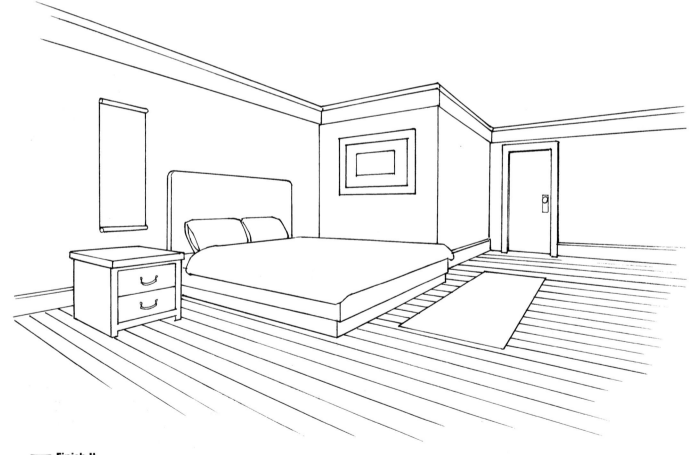

### 5 Finish It

Carefully ink it and let it dry then and erase the guidelines. You've done it! A real three-dimensional looking room, courtesy of the two-point perspective.

# Two Points

The uses of two-point perspective are truly endless. Once you start using it for objects and environments in your drawings you're going to be amazed at how solidly three-dimensional everything becomes. Provided you remember the rule about keeping the two vanishing points a healthy distance from each other, you're going to be able to able to apply this technique to almost anything.

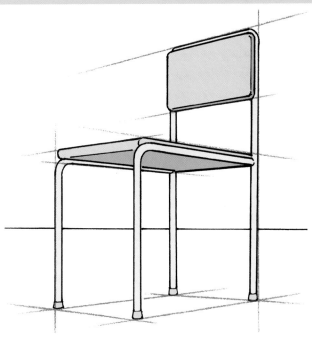

### By the Book
A stack of books, with all its horizontal lines, is a perfect candidate for two-point perspective.

### Sense of Perspective
See how it seems to pop out of the page? Compare it to the one-point perspective chair and you'll see what a difference the two-point approach makes.

Find more two point drawings online at **impact-books.com/mastering-manga.**

### City Dweller
A classic example of a two-point perspective: the modern cityscape. The boxy office towers are very cooperative about providing lines to send off in both directions. It takes patience, but a good ruler is all you need to make a drawing like this.

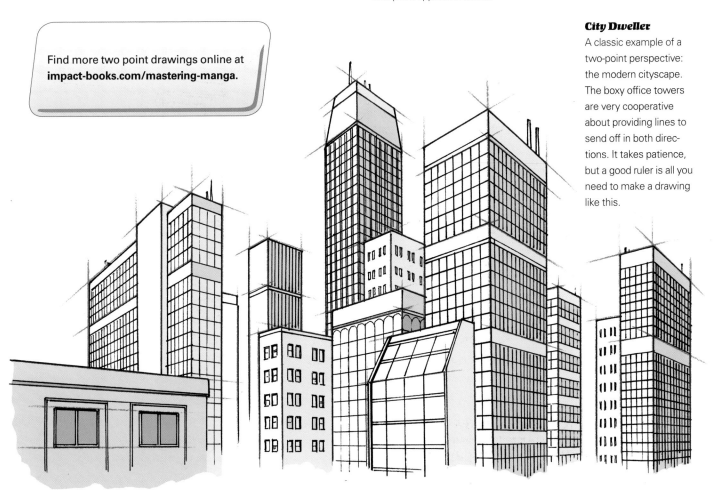

# Space Station Exterior Using Three-Point Perspective

Three-point perspective is by far the most complicated of the three perspective systems. Hold off on this lesson until you've mastered one-point and two-point perspective drawing.

Just to mix things up a little I've decided to move away from a standard aerial cityscape drawing—the most common example of three-point perspective—and go for a sci-fi space station instead. There's a method to my madness, though. This Death Star-ish environment is composed almost entirely of straight lines and saves us from the chore of drawing row after row of office building windows, tree-lined streets and bird's-eye view automobiles.

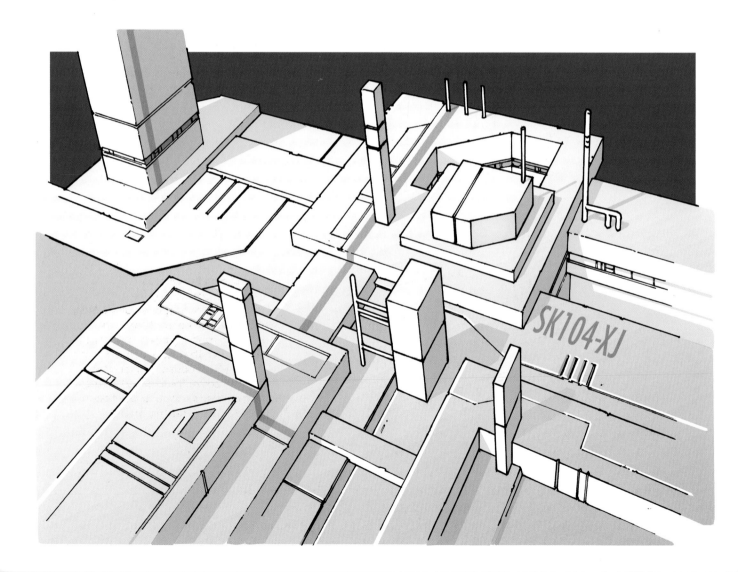

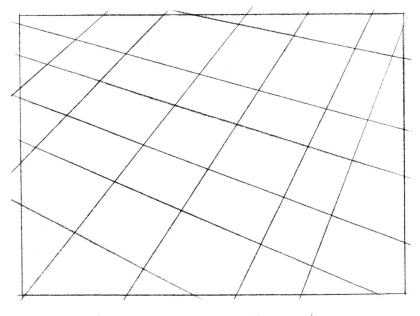

### Build Your Frame

1 Start with the very largest sheet of paper you can find and place your three vanishing points at the very edges. To get the lines, you'll need one vanishing point to be way up in the upper right-hand corner. The second vanishing point will be on the left near the upper corner. Using a good long ruler, draw a number of lines fanning out gently from both vanishing points, causing them to intersect in the middle of the page to create a checkerboard pattern.

### Add the Third Vanishing Point

2 Place your vanishing point at the very bottom of the page, slightly off center to the right. Use your ruler to create lines fanning out from it to the top of the page.

If you find that your lines are fanning out severely, it means your third vanishing point isn't far enough away.

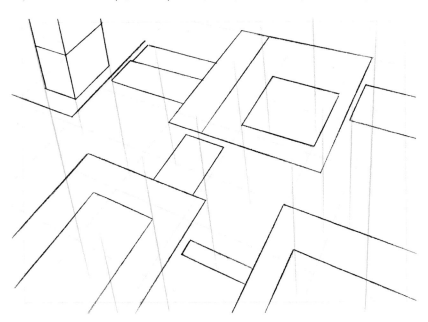

### Sketch the Shapes

3 Begin constructing the surface shapes of the space station. Nearly all of these lines connect only to the upper two vanishing points. As a result, they all lie flat. The only vertical element right now is the base of a tower in the upper left corner. The three vertical lines that compose this tower all point down toward the third vanishing point.

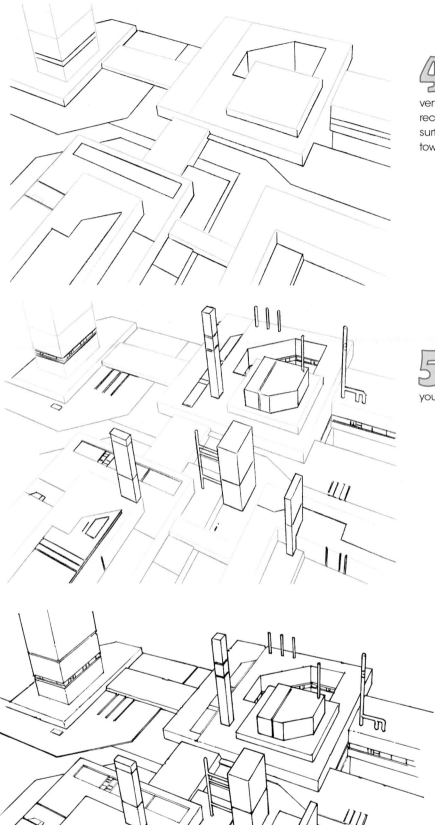

### Add Depth

**4** Draw more lines across the space station surface, as well as a few vertical lines that cause some of the rectangles to rise from or sink into the surface. All of these vertical lines taper off toward the lowest vanishing point.

### Fine-Tune

**5** Add in a few more vertical towers and stacks, making sure to keep your lines in perspective.

### Finish It

**6** Ink your drawing, relying on your ruler to make the lines perfectly straight. Let it dry, then erase the guidelines.

Pat yourself on the back. Your three-dimensional-looking space station is complete.

# Point of View

We tend to associate the three-point perspective with the bird's-eye view, and that is indeed the sort of drawing that absolutely depends on it. But this style of perspective can also be applied to pretty much anything. Dramatic scenes can be created when rooms, pieces of furniture and ordinary household objects are drawn in three-point perspective.

### Building Blocks
It doesn't have to be a vast cityscape to warrant the three-point approach. Even a tiny building block can be drawn this way.

### Musical Chairs
Now we see the same chair as rendered in three-point perspective. Compare it to the previous two versions to see the different points of view you get in each drawing.

### Well-Grounded
Everyone loves a good bird's-eye view, but the worm's-eye view is every bit as useful. This view of the city is the one we're all used to seeing. In this drawing pretty much every single line is heading off toward one of the three points.

# Inking Tips

A lousy drawing can't be saved with beautiful inking, but a beautiful drawing will still look okay even in the hands of a subpar inker.

Don't worry too much about your inking skills until you're comfortable with your drawing ability, but these tips will help you get started.

## Manga Inking vs. Comic Book Inking

American comic book artists ink with great value being placed on lines that vary in width and display the artist's dexterity with pen and brush.

However, the vast majority of manga artists ink with comparatively thin lines that don't vary much in width. Manga that includes thick, brush-applied lines is rare indeed.

## Keep It Clean

The main challenge with inking is to avoid smearing your lines while they're still wet. If it happens, it's not the end of the world. You'll make things easier on yourself if you start in one corner—the upper left if you're right-handed—and work your way down toward the opposite corner.

Whatever you do, don't rush it. Practice your inking techniques on a separate sheet of paper before committing them to the page.

# Putting Pen to Paper

The angle at which the pen hits the page affects the width of the line. Different brands of pens behave in different ways, so play around with the one you're using to see which angle produces which type of line.

**Tip-top Shape**

An angle perpendicular to the page often produces a thicker line. The ink flows from the very tip, not the sides. The trade-off is loss of some control.

**A Different Angle**

A lower angle produces a thinner line. Only the edge of the tip touches the page, so less ink hits the paper. Lighter pressure will give a thin, delicate line.

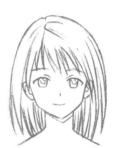

**All in the Wrist**

Use the natural pivot point of your wrist to make curving lines. Spin the page and position it so your wrist can produce the curving motion naturally.

## WRIST WORK

Warm up your inking skills by using what you've drawn in previous lessons to practice your pivot.

Remember me?

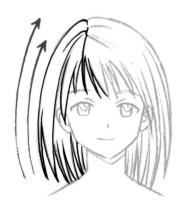

**1 Start on Your Left**
These curving lines will flow naturally from the pivot point of your wrist. Lefties will need to turn the drawing upside down.

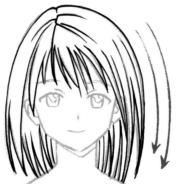

**2 Continue on the Other Side**
Spin the page and ink the lines on the other side. You may need to turn the girl's head upside down to get these lines to flow naturally with your wrist.

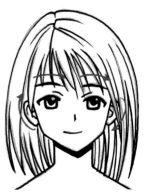

**3 Don't Resist**
You can ignore the natural flow when drawing shorter lines like the ears and eyebrows, but smooth longer lines are impossible if you're fighting your wrist's pivot point.

# Anatomy of an Inked Manga Illustration

A high-quality manga illustration holds a wealth of information about inking. Study it properly and it can provide you with a master class in the subject, free of charge. Here I've zoomed in on the lines that make up this picture so that you can see the qualities of the various lines and get a sense of how they were produced.

**Crosshatching**
Some manga artists use moderate crosshatching, most use it sparingly, and many don't use it at all. Still, if you like the look, it's a technique well worth adding to your arsenal.

Look closely at the girl's eyes. There is variation in the darkness of the hatching. This is achieved by layering in more lines at the top and fewer at the bottom.

**Long, Flowing Lines**
The key to this is in the speed of the individual pen strokes. You can't produce lines like this by clamping down on the pen and gritting your teeth. The pen needs to glide over the page in long, uninterrupted movements of the wrist.

**Bold Black Areas**
Filling in large areas of black doesn't take a lot of skill.

I inked the area shown here using a brush, deliberately allowing the strokes of the brush to be seen at the bottom. Such visible brushwork is pretty rare in real published manga, but if you like the look, it's a technique that can be used to good effect.

**Short, Choppy Lines**
Not all inking needs to be as graceful and difficult to master as the long, flowing lines seen in the hair. The lines composing the girl's fur coat can be dashed in with a minimum of fuss. If they are uneven and heading off in slightly different directions, so much the better, since that contributes to the fluffy effect.

# Crosshatching

Every artist comes up with his or her own style of crosshatching, but they all come down to the same basic idea: layering lines on top of each other to create the illusion of a fairly even tone.

**1** **Start With One Direction**
Make some parallel lines in a single direction. Your lines should be much smaller than this on the page.

**2** **Move to another**
Add the same number of lines on top, this time at a slightly different angle.
Pick a third direction to add yet another layer.

**3** **Repeat Until Satisfied**
Add more lines until a fairly even tone is formed.

## ADDING SPEED LINES

Even the casual observer of manga will notice the art form's copious use of speed lines.

Remember me from the fighting scene?

**1** **Mark Your Vanishing Point**
Make a dot outside the panel.
Grab your ruler. At the upper left corner, begin drawing lines from the top border to the vanishing point, allowing them to taper off into the white of the page for a kind of halo effect.

**2** **Add More Lines**
Keep the ruler firmly aligned with the vanishing point. Apply greatest pressure where the lines begin at the upper right side of the panel and gradually lighten until the pen no longer touches the paper.

**3** **Complete the Panel**
Most manga artists will leave white gaps between groupings. Without them the lines will blend together and begin to read as a single flat tone.

# Paneling and Page Layouts

You're a master of perspective and can draw your characters from head to toe. You're ready to make a manga, right?

Not quite.

All those drawing skills won't do you much good if you don't know how to lay out pages.

It's not that hard to figure out. Once you've got a few basic principles down...

...you'll be laying out pages with the best of them.

## Common Manga Panel Shapes

A comic book page layout is built entirely of panels, and those panels should be a natural outgrowth of the drawings held within them.

### Panorama

A cityscape is a naturally horizontal image, so it's screaming out for you to put it in a nice wide horizontal panel.

### Neutral Space

Many subjects are neutral in terms of the panel shapes they suggest. Go square to slightly horizontal or vertical depending on the space available on the page.

### Blow Your Top

A boy's head and torso is primarily a vertical image. Squeezing him into a horizontal one will end up lopping off the top of his head.

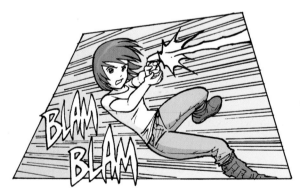

### Taking Shape

Manga artists often place characters in oddly shaped angular panels, especially during action scenes. The diagonal lines of the panel borders accentuate the sense of the story's world going off-kilter.

### Cornered

Circular and oval panels, common enough in American comics, are extremely rare in manga. Go for it if you like, but keep in mind how rare it is.

# My Process

"What do you do first, the writing or the drawing?" It's a common question.

With me, absolutely everything is an outgrowth of the story, so no question: it all begins with the writing.

*Talia led me from what was already one of neighborhoods into a part of town people calle... It was kind of a black hole of public schods, no garbage collection. After making our way down there, on the others and a graveyard of rusting refrigerators,*

### Step 1: Write

Here is an actual sample of the writing that gave birth to a page from my *Brody's Ghost* graphic novel series from Dark Horse Comics. It's all on the back of a piece of scrap paper, allowing me to cross things out with wild abandon and even chuck the whole thing in the waste basket if it's not going well.

### Step 2: Thumbnail Sketch

I'm still playing around on scrap paper, tossing down lines to get a sense of what will be in each panel and where the text will go. It's important that the text and images develop at the same time. Don't leave the text as an afterthought. If you anticipate the need for text in the earliest stage of your layout you can avoid the heartbreak of having to obscure beautiful art later on.

### Step 3: Pencil It

I switch to bristol board and lay in all the important details of the art. There will be changes between the thumbnail and the pencil as I arrive at different solutions to space and storytelling. The second paragraph of text, for example, was moved to allow more art there.

This is also where I show things to my editors so they have a chance to suggest changes.

### Step 4: Ink It

The editors have given me the green light, I've worked out most of the art issues, and I can focus on what I love most: making the art the best it can be. Having done the pencils on bristol board, I can ink directly on top of them and be done.

# Layout Sequences

One of the most common styles of setting up a comic book sequence is to begin with an establishing shot then work toward a close-up. These three panels provide a pretty straightforward example of how it works.

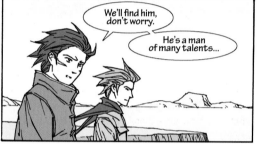

### Panel 1: Establish the Scene

The reader needs to know where the characters are. So the artist pulls back to reveal a lot of information: the desert locale, the exotic city in the distance and the two characters featured in the scene.

### Panel 2: Zoom In

The focus shifts to the conversation. It's unwise to jump straight to a close-up. The reader will get whiplash if we're suddenly right up in one of the guy's faces. By still keeping a little distance we create the feeling of a camera zooming in.

### Panel 3: The Close-Up

Now we can go all the way in and study the character's face. Having the character begin a sentence in one panel and finish it in the next is a nice way of stitching together the panels, allowing the story to flow from one moment to the next.

## Face-time

This simple four-panel sequence supplies a surprisingly large amount of information about the characters and how they feel about the things that are being said.

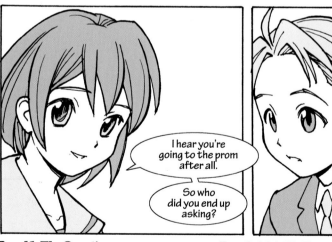

### Panel 1: The Question

This one is all set-up. The look on her face is innocent and fairly neutral: She has no idea what's coming.

### Panels 2 & 3: He Reacts

Deprived of dialogue, the reader must focus on the boy's look of surprise. The reader hears a pause in the conversation.

In panel 3, we watch his face change to a look of embarrassment when he sheepishly answers the question.

### Panel 4: Her Reaction

This panel retains an echo of panel 1. There is humor as we see the drastic change in her facial expression. Master this style of storytelling and you'll know the secret to making your readers want to see what happens next.

# To Panel or Not: Different Layouts

There's incredible variety in the way manga pages are laid out, but they generally fall into one of three categories, laid out below.

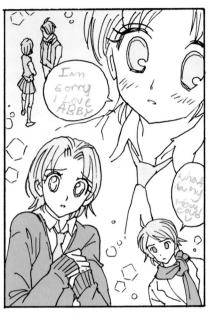

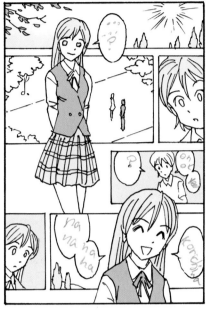

### All Panels, All the Time

This approach is especially evident in shonen action-oriented manga. The artist wants to put the story out there in a straightforward way and stays away from experimental layouts that call a lot of attention to themselves.

### Panels? What Panels?

It's exceedingly rare for an entire story to be told this way, but shojo manga will occasionally opt for this approach. The effect is to create a dreamy feeling of having entered the main character's head, inhabiting her emotional state and leaving the real world—and the panels— behind.

### The Best of Both

Of course, there's a compromise: good, old-fashioned comic book storytelling that sometimes dispenses with panels, creating interesting layouts that are easy to follow but also playful. I got hooked on this approach in my *Miki Falls* series and found myself wanting to experiment with such layouts on almost every page.

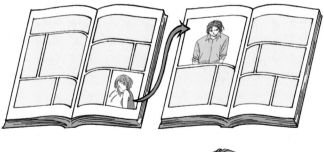

## Spoilers!

Put the big reveal in the first panel of a left-hand page. Readers can't see it until they turn the page so they'll get the ultimate shock. If you put the surprise panel anywhere else, the readers will see it too soon and the dramatic opportunity will be lost.

# Making Your Own Manga Sequences

Okay, enough practice! You guys are more than ready to start putting some of this into practice This simple lesson will allow you to go beyond character poses and get your hands dirty with some honest-to-goodness storytelling. You know the drill: Pencils first, inks at the end.

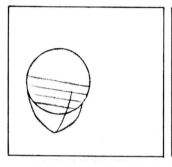 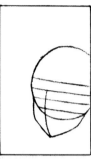 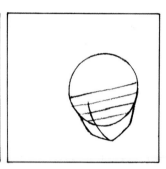

**1 Build Your Frames**
Using your ruler, draw three panels. In each panel draw the rough guidelines of three heads, using the face three-quarter view. Give each head a bit of a tilt if you like.

**2 Add Features**
Add the hair, shoulders and facial expressions. Do you have to work on all three panels at once? Absolutely not. Take them all to final one at a time if that's what works for you.

**3 Add Details**
Change the hairstyles or other details to make them your own.

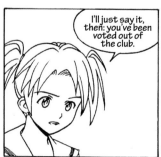  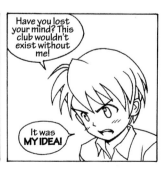

I'll just say it, then: you've been voted out of the club.

Have you lost your mind? This club wouldn't exist without me!

It was MY IDEA!

**4 Finish It**
Ink it and let dry, then erase the guidelines.

# Making the Leap: Advanced Sequencing

So far, I've kept the lessons in this book simple and easy to follow. But now, you're ready to move to the next level.

The difference between steps one and two is like night and day, but if you take a closer look, you'll see that the components of the drawing are based on our previous lessons, so feel free to return to those anytime.

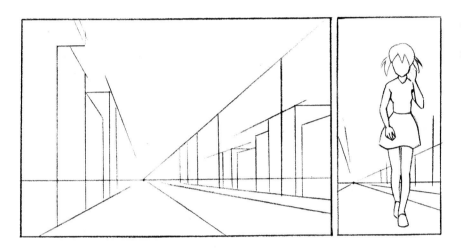

### 1 Set the Scene

Draw two panels, one horizontal, the second vertical. In the first panel, draw a one-point perspective sidewalk scene. In the second panel, outline a girl walking toward the reader. Draw one of her hands up near her ear. Once you've got her in place, sketch in a bit of the background so that this scene will read as a continuation of the first panel.

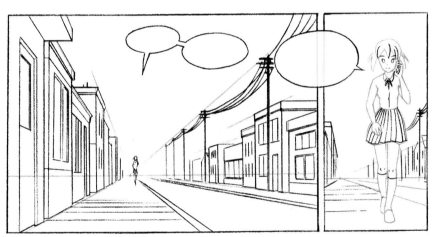

### 2 Sketch the Details

Add telephone lines and some details to the buildings.

Add word balloons. These are based on dialogue I came up with, but your dialogue may be completely different, resulting in different word balloons.

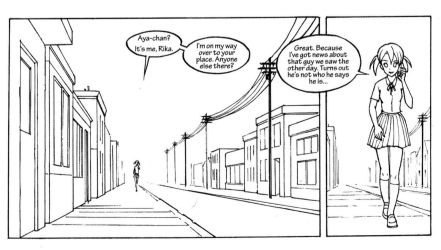

### 3 Ink It

Ink and add lettering to the word balloons. Once the ink's dry you can erase and kick back to admire your own handiwork.

# Can We Talk?
# Word Balloons

Word balloon placement may not seem like the most thrilling aspect of comics creation, but wise artists will focus on it and plan their pictures around it. Nothing pulls a reader out of the story more jarringly than confusion over the reading order of the word balloons.

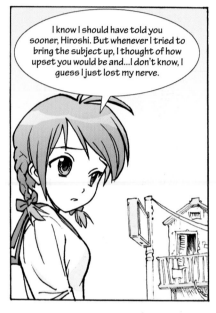

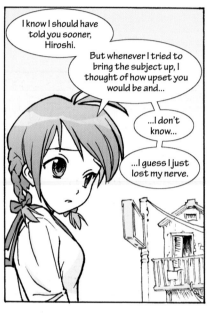

### Turning Word Balloons Into Nuggets of Speech

Failing to break a big paragraph of speech into smaller components robs you of your opportunity to suggest pauses in speech. Read these two examples and see if you don't hear them differently in your head.

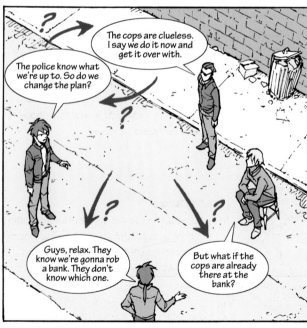

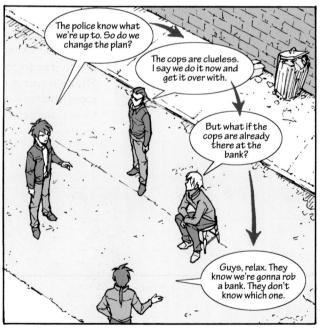

### Word Balloon Placement

In this version, there is ample opportunity for the reader to read things in the wrong order, thereby destroying the logic of the conversation. Don't give them that opportunity!

### Direct the Eye

Here, the reading order is crystal clear: your eye moves naturally from sentence to sentence as they flow from top to bottom in a curving string of balloons.

Move the characters closer together if need be. This kind of thing should be worked out early so you don't have to make time-consuming changes later on.

# Make Some Noise

Almost all comics employ sound-effect words of some kind. The manga approach is distinctive, sometimes suggesting sounds for things that are silent, like the sun's glare in the sky.

You have to be careful with sound effects not to overdo it. We don't need to hear the birds chirping throughout the entire picnic scene. Give us a CHIRRUP or two in the first panel, then let us use our imaginations after that.

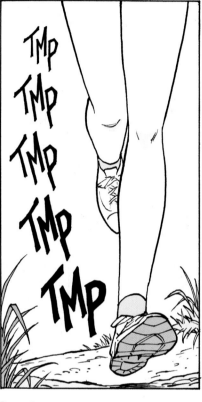

**Using Lettering to Suggest Sound**

The shape of the letters plays a big role in conveying the sound. The liquidy look of the SPLOOSH helps us hear the water. The hard-edged sharp lettering used for SHING makes the sound effect come across as high-pitched and metallic.

**Repeat**

A small, repeating word may gradually grow larger, creating the sensation of the sound gradually getting closer. Some Japanese sound effects like TMP have become standardized by translators as the go-to words for those particular noises.

**Big Bang**

Action-packed stories often call for big, earth-shaking sounds. Unlike their American counter-parts, manga artists will often break a single big sound into pieces and spread it across a whole panel.

Big jagged letters help convey the thunder-ous nature of the sound. (Jeez, I hope that guy's okay.)

# Conclusion

Well, that's it, friends: we've reached the end of the book.

I really hope you'll find it helpful.

Creating a manga story is way more challenging than most people realize.

It demands drawing skills, writing skills, layout skills...

and a massive amount of visual imagination.

More than anything else it requires determination to keep at it, day in and day out...

year after year...

until your manga artwork is just as good as the stuff you see in the bookstores.

So what are you waiting for? Grab your pencils and get to work!

I'm counting on all of you to be the manga creators of tomorrow.

And if anyone tells you you'll never make it in manga,

you tell 'em Mark Crilley says you will.

There's always room in the world for one more great manga series.

Why shouldn't it be yours?

# Index

## About the Author

Mark Crilley is the author and illustrator of several graphic novel and prose fiction book series, including thirteen-time Eisner nominee Akiko, Billy Clikk, *Miki Falls* and *Brody's Ghost*. Since being selected for *Entertainment Weekly's* "It List" in 1998, Crilley has spoken at hundreds of venues throughout the world and become one of YouTube's top 25 Most Subscribed Gurus, creating drawing demonstration videos that have been viewed more than 60 million times. His work has been featured in *USA Today,* the *New York Daily News* and *Disney Adventures* magazine, as well as on Comcast On Demand and CNN Headline News.

This book is dedicated to my YouTube subscribers. This book would truly not exist if not for all of you and your many years of support.

Other fine IMPACT Books are available from your favorite bookstore, art supply store or online supplier. Visit our website at fwmedia.com.

20  19  18  17     21  20

DISTRIBUTED IN CANADA BY FRASER DIRECT
100 Armstrong Avenue
Georgetown, ON, Canada  L7G 5S4
Tel:  (905) 877-4411

DISTRIBUTED IN THE U.K. AND EUROPE
BY F&W MEDIA INTERNATIONAL LTD
Brunel House, Forde Close, Newton Abbot, TQ12 4PU, UK
Tel: (+44) 1626 323200, Fax: (+44) 1626 323319
E-mail: enquiries@fwmedia.com

DISTRIBUTED IN AUSTRALIA BY CAPRICORN LINK
P.O. Box 704, S. Windsor NSW, 2756 Australia
Tel:  (02) 4577-3555

Edited by Vanessa Wieland
Designed by Guy Kelly
Production coordinated by Mark Griffin

### Metric Conversion Chart

| To convert | to | multiply by |
|---|---|---|
| Inches | Centimeters | 2.54 |
| Centimeters | Inches | 0.4 |
| Feet | Centimeters | 30.5 |
| Centimeters | Feet | 0.03 |
| Yards | Meters | 0.9 |
| Meters | Yards | 1.1 |